DIRECT response graphics

ROCKPORT

THE **best** PRINT AND
ELECTRONIC direct mail
MARKETINGS

DIRECT **response**
graphics

Cheryl Dangel Cullen

GLOUCESTER MASSACHUSETTS

ROCKPORT
PUBLISHERS

First published in the
United States of America by
Rockport Publishers, Inc.
33 Commercial Street
Gloucester, Massachusetts 01930-5089
Telephone: (978) 282-9590
Facsimile: (978) 283-2742
www.rockpub.com

ISBN 1-56496-629-1

10 9 8 7 6 5 4 3 2 1

Design: Leeann Leftwich
Cover Image: Stock photo, Photodisc
Illustration: Leeann Leftwich

Printed in China.

Dedication

TO: T.J.C.

WE'LL SHOW
YOU HOW *FOR FREE*

contents

INTRODUCTION

DIRECT–RESPONSE MARKETING. If the phrase sounds new, it is. We know it better by the old standby definition—direct-mail marketing. The term *direct mail* now falls far short of conveying the range of options available to strategic marketers today.

It comes as no surprise that direct mail no longer is delivered exclusively by the postal service. It comes in all shapes, sizes, and formats. It can arrive by E-mail or take the form of an idle Internet site, passive until a visitor surfs in. Then, it springs to life, inviting and prompting successive responses at a click of the mouse. For these reasons, direct-response marketing is generally agreed to be the more apt term, but the objective remains the same as always: to bring about a desired response in the target or prospect. The goal might be to persuade the recipients to give their time or their money, to place a telephone call, to make a purchase, or to join an organization. Many

responses are possible, but the overriding question remains: *How does one elicit such responses in a world crowded with dozens of outside influences vying for attention?*

Direct–Response Graphics: The Best Print and Electronic Direct–Mail Marketings was created to provide some answers. In this book, you'll find more than 130 targeted response pieces from over seventy-five designers in studios within fifteen countries. They are effective not merely for their design, but for the results they earned. The pieces in this collection all work because the synergy of the design and copywriting are on target, so much so that these examples warmed and then won over the prospect to the desired action.

Once warmed to an idea, a target is receptive to action—whatever that might be. The designs on the following pages are excellent examples of how to warm up the otherwise dreaded cold call. To make the process even easier, each chapter opens with a working tip from marketing pro Morgan Shorey, president and founder of The List®, whose business it is to help members of the creative industry market themselves. Her ideas can help establish some guidelines and erect the framework for a direct-response campaign.

Pleas to give of their time, their money, and their effort barrage consumers daily. A marketing approach that knows how to cut through the clutter and motivate the recipient to read, recognize, and react can mean the difference between a hard-won result and an effort that ends up in the wastebasket or recycling bin before anyone opens it.

Boosting Enrollment
and Membership

"Address the benefits of membership or attendance. Be sure the offer of membership offers value and that the value emerges clearly in your pitch. People will be reluctant to join any organization that looks shallow or without real benefit.

"If there is a deadline for sign-up, encourage a timely response by offering a free T-shirt or a discount if they enroll by your target date. Offer incentives for members who bring in new members.

"You may also want to include quotes from industry notables. Someone else who is recognizable to your target audience is the best endorsement possible."—Morgan Shorey, The List®

Whether recruiting members for an organization or attendees for a conference or seminar, or soliciting prospective college students, this form of direct marketing requires a commitment. Given society's demands on our time, direct-response pieces that successfully boost enrollment and membership are those designed with the magnitude of this commitment in mind. Few things are more precious in today's 24/7 lifestyle than time.

Pieces that successfully persuade individuals to give up a day's work to attend a seminar, a year of Thursdays for board meetings, or, in the case of students looking for a college, the next four years of their lives, are those that tout the value of joining. They answer the top-of-mind question, "What's in it for me?" The benefits may be clear-cut and factual, or they may be emotional; either way, effective marketing pieces put the message front and center.

Once a prospect understands the value of joining, the next question is, "Will I fit in?" Few people like to admit that this is important, but fewer still feel comfortable mingling in a room full of people with nary a familiar face in sight. With this in mind, communications that reassure the prospect that the event or organization is tailor-made to their interests and needs strike at the heart of the matter—the emotional connection that binds people to a group. Graphically, designs achieve this with familiar scenes and happy, fun-loving people enjoying life, work, or college studies; people with whom the prospect can readily identify graphically represent these emotional ties.

Today, with so much competing for our time—work, family, the Internet, television, radio, newspapers—print and electronic marketing has to speak above the din, communicating its values loud enough to be heard. Taking a cue from the term *membership drive*, successful recruiting tools energize and drive toward success. The recruiting pieces featured in this section achieved their goals with lively graphics, innovative typestyles, and dynamic color palettes, some of which are bold while others warmly reassure. Moreover, these pieces delivered what the recipients wanted and needed in return for their commitment—the promise of value and connectivity.

TRAINING WORKS, FALL 1998 BROCHURE

Design Firm: Terrapin Graphics
Art Director/Designer/Illustrator: James Peters
Client: Workers Health and Safety Centre
Printer: MPH Graphics Inc.

Paper Stock: Jensen Satin 80 lb. text
Printing: 4-color process, sheetfed
Print Quantity: 50,000

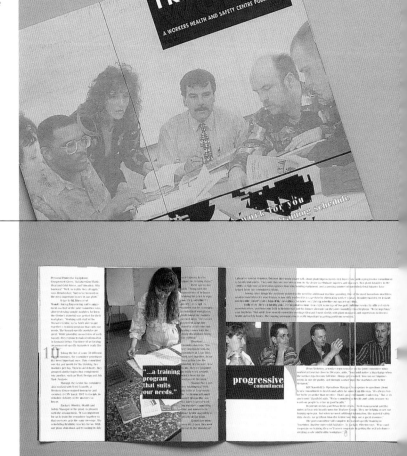

Terrapin Graphics designed this brochure to invite representatives from management and labor to participate in the Workers Centre courses on health and safety. "The client wanted a piece that would be distinctive and would, by its appearance, filter itself out of all the other mail received," said James Peters. As a result, Peters opted for an unconventional size and a magazine format that presented the information in easy-to-read articles. The mailer was so successful that extra courses were added to accommodate demand.

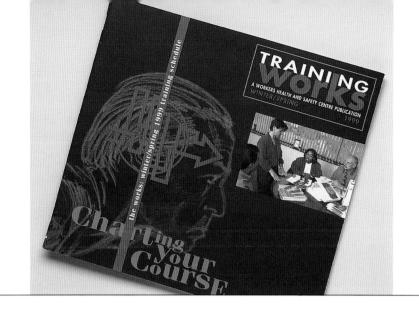

TRAINING WORKS, SPRING 1999 BROCHURE

Design Firm: Terrapin Graphics
Art Director/Designer/Illustrator: James Peters
Client: Workers Health and Safety Centre
Printer: MPH Graphics Inc.

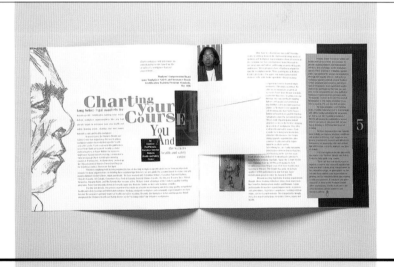

Paper Stock: Jensen Satin 80 lb. text
Printing: 4-color process, sheetfed
Print Quantity: 50,000

The Workers Health and Safety Centre decided not to mess with a good thing following the success of the autumn 1998 brochure/mailer designed by James Peters of Terrapin Graphics. So the Centre and Terrapin kept the format of the spring 1999 issue intact but updated the graphics. Once again, the brochure succeeded. The Centre had to add classes to accommodate enrollment. Some recipients, impressed with the brochure's appearance, contacted Terrapin Graphics for their own design needs.

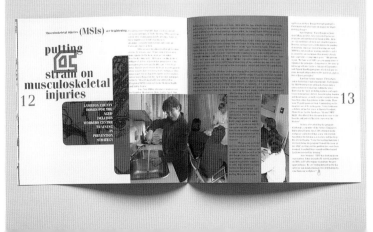

Design Firm: Anne-lise Dermenghem
Art Director/Designer: Anne-lise Dermenghem
Client: Association for Technical Coordination
in the Food Industry (ACTIA)

Project

Registration

N.

Surname
Nom

Project

N.

First name
Prénom

Title of Project
Titre du projet

Keywords
Mots clés

Project description
Description du projet

Expertise skills offered
Compétence et expertise offertes

Expertise skills soug
Compétence et expertise rech

Prof

PARIS

MAY 7th 1999
7 mai 1999

BROKERAGE EVENT
FOR SMEs
WITH R&D NEEDS

CONVENTION D'AFFAIRES
POUR LA R&D DES PME

Food
Alimentation

Nutrition
Nutrition

and Health
et Santé

BIT

Paper Stock: Papier couché Matillant 200 g.
Printing: 4-color process plus 1 PMS color, offset
Print Quantity: 3500

This invitation's clean, fresh, and organized layout demands notice. The cover presents the date and event's title cleanly—in both French and English. Inside, the program is unintimidating, uncluttered, and easy to follow—even though every line of copy is presented in two languages. One would think that, given the generous white space allowed for the introductory copy, the enrollment form would be tight on space. Fortunately, it's not. The reply card is equally clean with plenty of room for even the most expansive handwriting. The design makes it easy to sign up for the event and virtually assures a high turnout.

MERCURY INTERACTIVE SEMINAR
SERIES DIRECT MAILER

Design Firm: Oh Boy, A Design Company
Art Director/Designer: David Salanitro
Photographer: Hunter Wimmer
Copywriter: Carol Baxter (Mercury Interactive)
Client: Mercury Interactive Corporation
Printer: Nahan

Paper Stock: Eastern Smooth Opaque 70 lb.
Printing: 4-color process, plus 2 PMS colors, and flood dull varnish, full web
Print Quantity: 290,000

This tongue-in-cheek approach to direct-mail marketing, designed to increase attendance at Mercury Interactive seminars, grabs attention by equating the ease of e-business application testing to cheating. The headline—Cheat, We'll Show You How—is risky. So is the graphic of crib notes written on the test-taker's palm. As a result, the piece accomplished what it set out to do—to increase awareness of the seminars and, thus, to raise attendance.

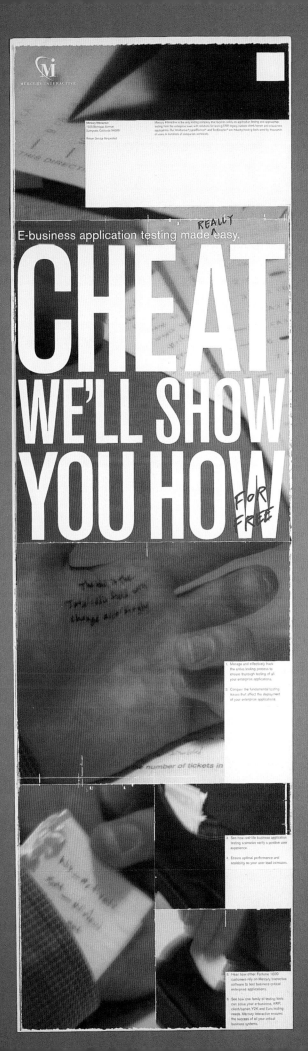

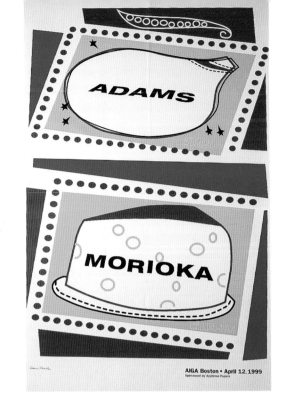

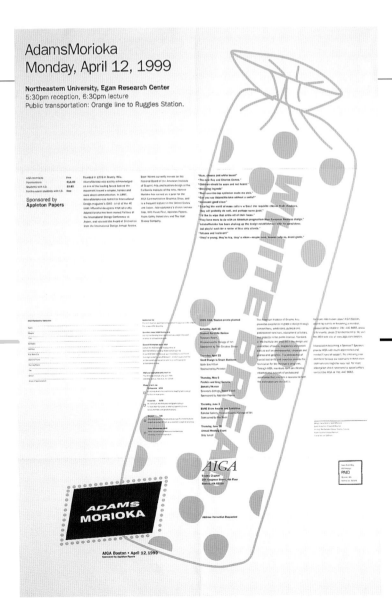

AMERICAN INSTITUTE OF GRAPHIC ARTS (AIGA)/BOSTON POSTER

Design Firm: AdamsMorioka
Art Director/Illustrator: Sean Adams
Design Firm: AdamsMorioka
Art Director/Illustrator: Sean Adams
Client: AIGA/Boston

Paper Stock: Appleton Utopia Premium Blue White Silk 100 lb. text
Printing: 4 PMS colors and black, offset
Print Quantity: 1000

To encourage attendance at this AIGA/Boston event sponsored by Appleton Papers, designer Sean Adams proposed taking a light attitude—employing a large graphic of white bread as the primary graphic offset with various quotations. "We intentionally used positive and negative quotes from different publications on the backside of the poster," said Adams. "Rather than using the standard designer bio, 'tons of awards, big clients, etc.,' the quotes challenge the recipient to attend the event and [to] make their own decision. Are we saints or bozos?" It worked. Approximately 200 people attended, the largest turnout for the year.

SWISS PLUS SEMINAR INVITATION

Design Firm: Gottschalk + Ash International
Art Director: Fritz Gottschalk
Designer: Regina Rodrigues
Copywriter: GCI London
Client: Swiss Bankers Association
Printer: Vontobel

Paper Stock: Invitation—Distinction high white 250 g., Letterhead—Distinction with watermark, high white 100 g., Envelope—Distinction high white 120 g.
Printing: 2 colors, offset
Print Quantity: 500

A comprehensive collection of matching invitations and letterhead was used to introduce a new Swiss partnership and to encourage key financial people to attend a two-day event in London. Each activity had its own invitation. Each invitation was designed in the same sophisticated, high-style format, devoid of clutter, relying on a bold color scheme for its high impact, a departure from traditional financial blue-color palettes. The reply card is impossible to miss. It is oversized with plenty of space for the largest scrawl, so responding couldn't be simpler. The event proved so successful that Gottschalk + Ash International has been asked to do a repeat performance for a similar event in Germany.

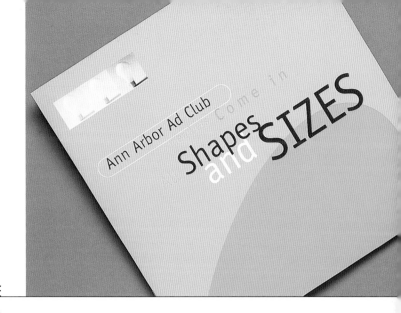

ANN ARBOR AD CLUB MEMBERSHIP BROCHURE

Design Firms: Delancey Design, Somberg Design
Designers: Jane Delancey, Marty Somberg
Photographer: Bob Foran
Copywriter: Christina Ladd Breed
Client: Ann Arbor Ad Club
Printer: Spectrum Printers

Paper Stock: Patina 80 lb. cover and text
Printing: 5 PMS colors, offset, and die-cut
Print Quantity: 2000

Recognizing that potential members come in all shapes and sizes, this membership recruitment brochure makes good use of shapes and sizes throughout—from its square cover presentation to downsized square text pages with the headline, "We're Upsizing!" The back pocket has two geometric die-cuts that hold ancillary information, including the membership form, and most interesting, a circular die-cut call for entries. In all, the message is neatly packaged, and the sherbet palette is refreshing. Pretty packages that are pleasing to the eye alone don't make successful direct-response mailers. Fortunately, this one did, generating a 15 percent increase in membership.

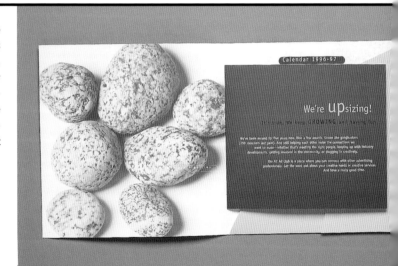

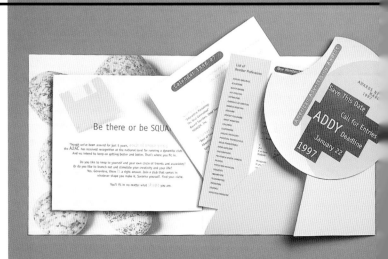

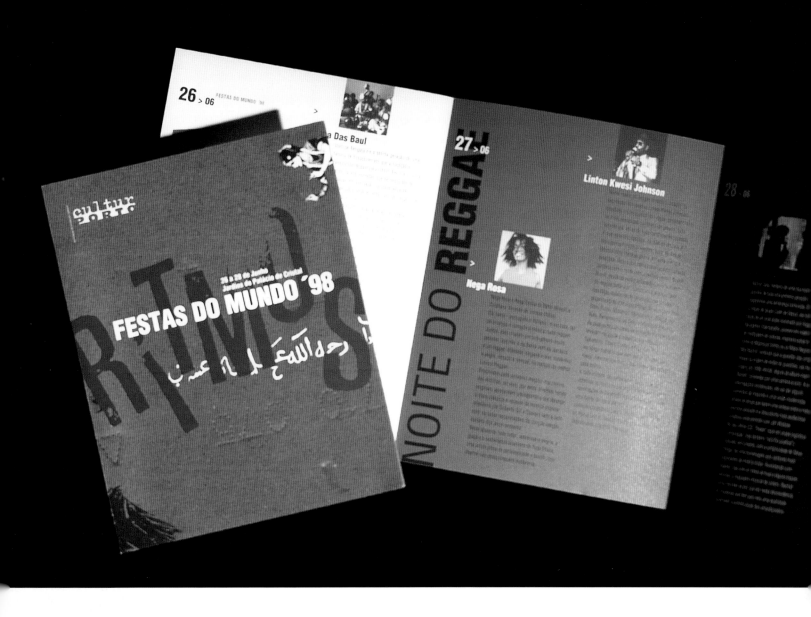

RHYTHMS MAILER

Design Firm: R2 Design
Art Directors/Designers: Lizá Defossez Ramalho, Artur Rebelo
Client: Culturporto/Pã design
Printer: Litogaia

Paper Stock: Munken paper 140 g.
Printing: 4 over 2, offset
Print Quantity: 3000

The energized color palette and gritty feel of this mailer heightened awareness for an upcoming ethnic festival that featured the music of three countries. While the graphics reflect each culture, designers maintained the unity inspired by the global festival.

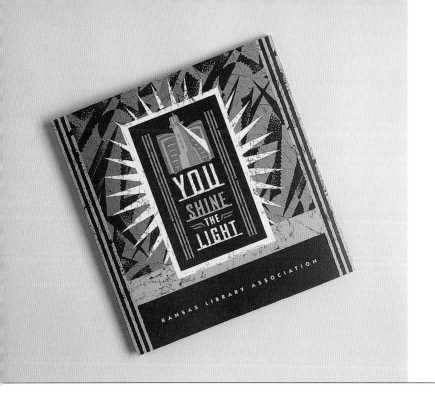

KANSAS LIBRARY ASSOCIATION
SHINE THE LIGHT MEMBERSHIP MAILER

Design Firm: Greteman Group
Art Directors: Sonia Greteman, James Strange
Designer/Illustrator: James Strange
Copywriter: Raleigh Drennon
Client: Kansas Library Association
Printer: Printing Inc.

Paper Stock: French Speckletone Kraft
Printing: 4 colors, offset
Print Quantity: 2500

When people perceive that an organization is tired, it's tough to build membership. To reenergize the Kansas Library Association, and ultimately to boost membership, the Greteman Group created this eclectic mailer by using trendy colors, dynamic illustrations, and a comprehensive reply card. The combined elements created a strong communication that generated the desired response. Reliance on illustrations instead of photography minimized costs.

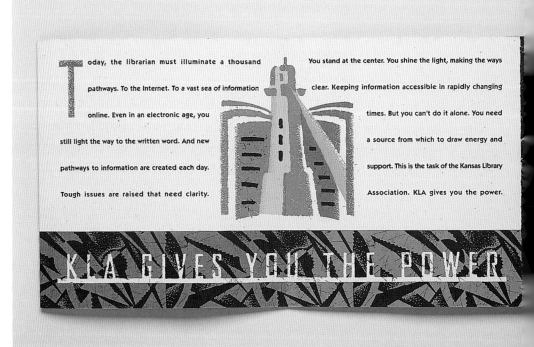

Today, the librarian must illuminate a thousand pathways. To the Internet. To a vast sea of information online. Even in an electronic age, you still light the way to the written word. And new pathways to information are created each day. Tough issues are raised that need clarity.

You stand at the center. You shine the light, making the ways clear. Keeping information accessible in rapidly changing times. But you can't do it alone. You need a source from which to draw energy and support. This is the task of the Kansas Library Association. KLA gives you the power.

KLA GIVES YOU THE POWER

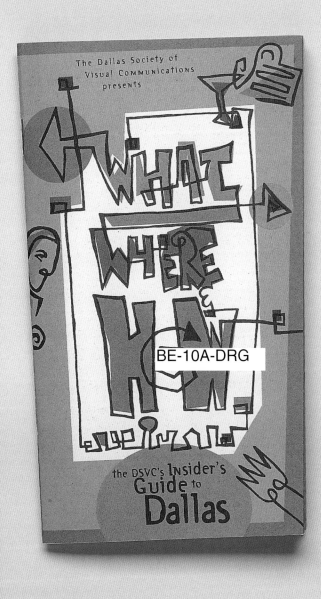

BE-10A-DRG

DALLAS SOCIETY OF VISUAL COMMUNICATIONS INSIDER'S GUIDE TO DALLAS

Design Firm: Studiografix
Client: Dallas Society of Visual Communications
Printer: Williamson Printing Corporation

Paper Stock: Neenah Classic Pebblestone 80 lb. text
Printing: 4 over 4, sheetfed
Print Quantity: 3000

Motivating designers to attend a seminar is difficult. To move them to purchase an airline ticket and a hotel room, and to reserve a few days to attend a conference is even tougher, even if it is the *How* Design Conference. A mailer alone, even this one, won't do the job. But because this brochure clued designers in on the things to do in Dallas during their stay, it gave them plenty of additional reasons to go. Many designers acknowledged that the guide helped them and allowed them to combine business with pleasure.

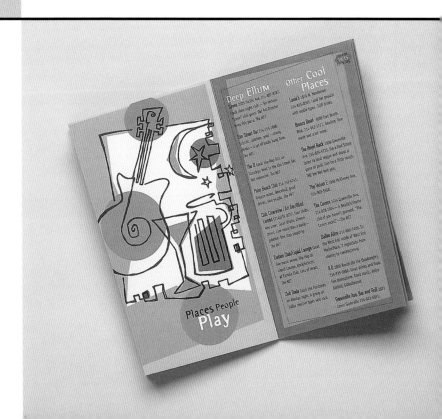

SCHOLARSHIP AND GUIDANCE ASSOCIATION
OPERA COMIQUE BENEFIT INVITATION

Design Firm: Lowercase, Inc.
Art Director/Designer: Tim Bruce
Copywriter: Chris Kadow
Client: Scholarship and Guidance Association
Printer: Dupligraphics

Paper Stock: Cougar Opaque 65 lb. cover and 70 lb. text
Printing: 2 PMS colors and varnish, offset
Print Quantity: 2500

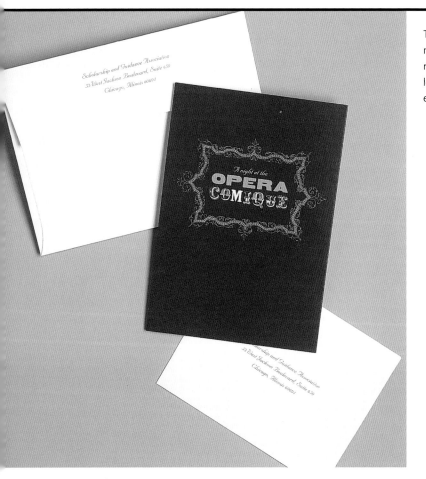

The typestyle and color give this invitation a decidedly European flair and help make this fundraising dinner a must-attend event. The understated reply card requests more than an RSVP. It also asks attendees to check off their contribution level and type of payment. This request may prove intimidating, but the very exclusivity of the event could prove irresistible.

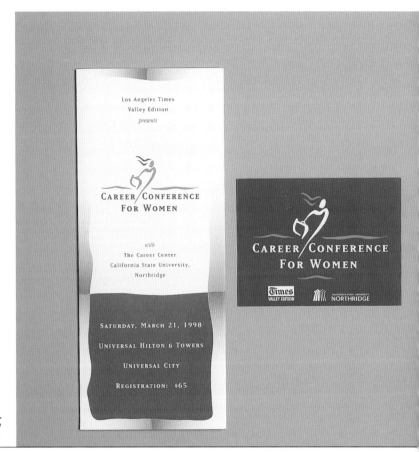

LOS ANGELES *TIMES*
CAREER CONFERENCE BROCHURE

Design Firm: Julia Tam Design
Art Director/Designer/Illustrator: Julia Tam
Client: Los Angeles *Times*

Printing: 2 colors, sheetfed
Print Quantity: 5000

The budget to promote this event was limited, so the design for the brochure was intentionally kept clean and simple; it doubled as a black-and-white newspaper ad. The registration form is equally clean. Together, the pieces won many sponsors for the first-ever event and generated high attendance at the conference.

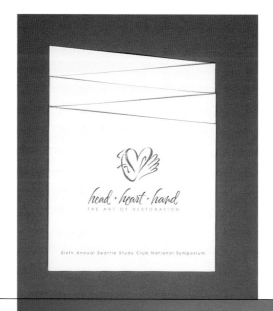

SEATTLE STUDY CLUB SYMPOSIUM BROCHURE

Design Firm: Hoffmann & Angelic Design
Art Director/Designer: Andrea Hoffmann
Illustrator/Calligrapher: Ivan Angelic
Client: Seattle Study Club

Paper Stock: Neenah Classic Crest Solar White Cover
Printing: 2 colors, offset
Print Quantity: 4500

The Seattle Study Club's Symposium brochure resulted not only in a sold-out seminar, but also in a marvel of creative cost-saving effectiveness. To stay within a limited budget—unlike previous years' invitations that were creative yet increasingly costly—this version was designed cleverly with an accordion fold that appears to be die-cut but, in fact, only is trimmed. The brochure was printed two-up on the sheet, and each was placed top to top so that there would be only one straight trim. The excess stock—nearly four inches—was not wasted. This space was filled with menu cards, business and name cards, and other small items—consolidating multiple pieces into a single press run with simple straight cuts.

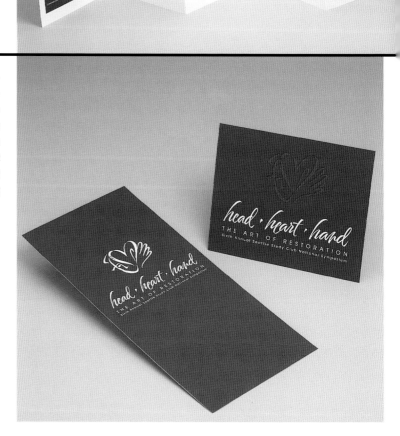

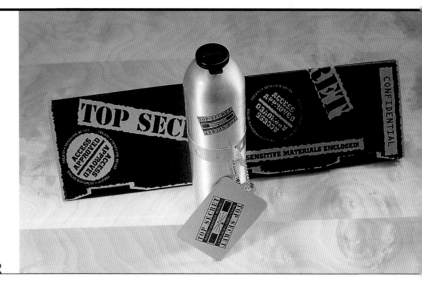

COLEMAN TRADE SHOW MAILER

Design Firm: Love Packaging Group
Art Director/Photographer: Chris West
Designer/Illustrator: Rick Gimlin
Client: Coleman
Printer: Rand Graphics

Paper Stock: Corrugated (B-Flute)
Printing: 1 color, silk-screened
Print Quantity: 100

To encourage attendance at a trade show, Coleman's teaser mailer used a top-secret and confidential theme to pique interest in a product that didn't even have a name yet. There wasn't much of a budget either, which necessitated one-color printing. Nevertheless, this object mailing put something tangible into the hands of its recipients, making it all the more memorable.

CRUISE WEST INVITATION

Design Firm: Belyea
Art Director: Patricia Belyea
Designer: Kelli Lewis
Copywriters: Steve Gray, Liz Holland
Client: Cruise West
Printer: GAC/Allied Printers

Paper Stock: Invitation and Insert Card—Strathmore Elements Solids Bright White, 80 lb. cover, A-7 Envelope—Strathmore Elements Solids Bright White 70 lb. text
Printing: 4-color process, sheetfed
Print Quantity: 15,000

Forty different versions of this Cruise West three-panel invitation were created, with different seminar dates and locations, to make it easy for travel agents to attend. The reply card was printed four-up in order to control costs. The specific seminar dates and locations were laser printed on each card, then trimmed out and inserted into the main invitation.

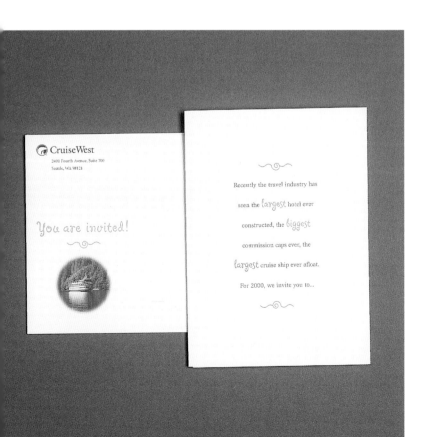

OHIO ARTS COUNCIL'S 1998 CONFERENCE ON THE ARTS REGISTRATION BROCHURE

Design Firm: Base Art Co.
Art Director/Designer: Terry Alan Rohrbach
Illustrator: Kirk Richard Smith
Copywriter: Charles Fenton (editor)
Client: Ohio Arts Council
Printer: Dispatch Color Press

Paper Stock: Navajo 65 lb. cover
Printing: 4-color process plus 1 PMS color, sheetfed
Print Quantity: 5000

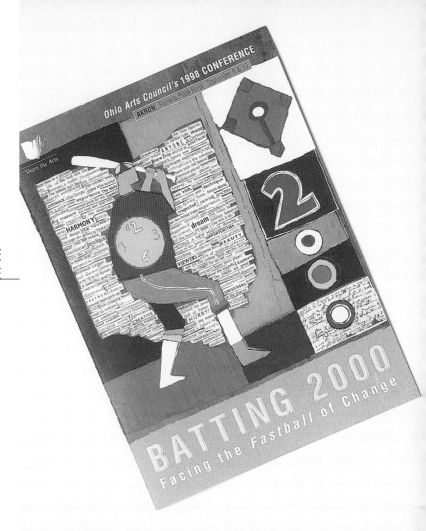

The purpose of this statewide event was to show how artists and art enthusiasts could prepare for all the changes in 2000 and beyond. A visual theme communicated the message—the fastball of change—and the resulting illustration branded the entire conference. The style of the cover illustration and its wood-textured background carried throughout the brochure. Copy was written and laid into the design to make it easy for the reader to follow and ultimately to register for the event. Many signed up; registration exceeded all expectations.

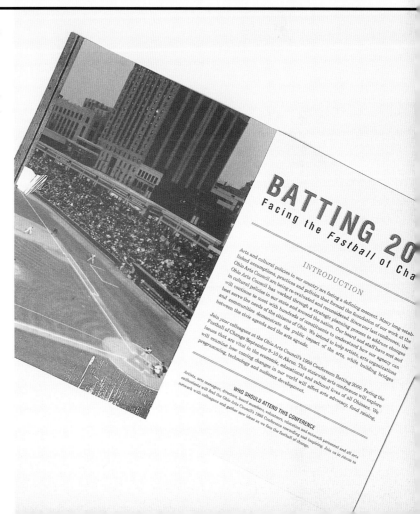

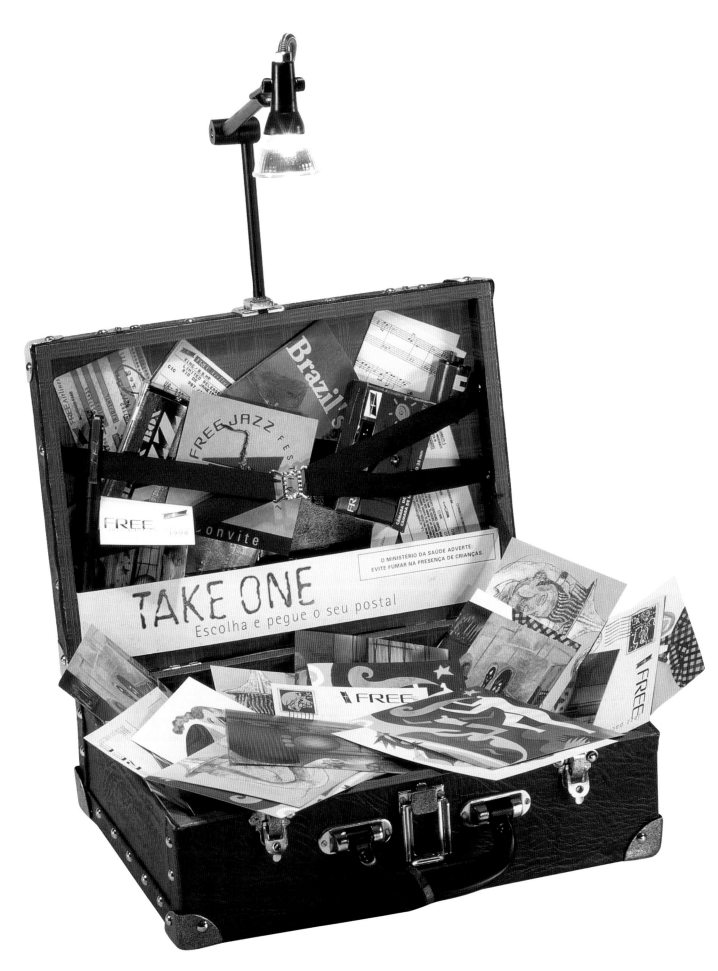

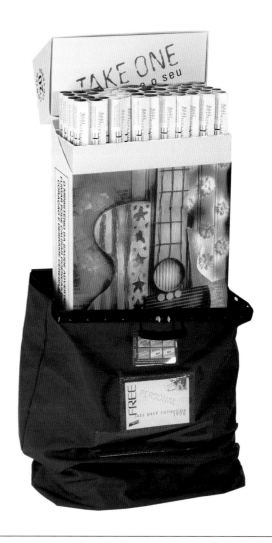

SOUZA CRUZ
FREEJAZZ FESTIVAL PROMOTION

Design Firm: Ana Couto Design
Art Direction/Design/Illustration/Copywriting: Ana Couto Design
Client: Souza Cruz

Paper Stock: Posters—Couché Matt 150 g/m², Postcards—Supreme cardboard 250 g/m²
Printing: Posters—5 over 5, Postcards—5 over 2, offset
Print Quantity: Posters—11,000, Postcards, 41,920, Displays 840

Ana Couto Design created an award-winning promotion for the Free Jazz Festival, an event sponsored by Free, a brand of cigarettes. The all-encompassing promotion included every aspect of marketing from issuing limited-edition product packaging to point-of-sale promotions and more. Several direct-response components also were included.

Free posters were rolled to look like cigarettes and were packaged in an oversized cardboard display that resembles an open pack. The display was inserted into a large pouch to give the impression that the festival had just arrived and would depart again soon. To garner visibility in high-end restaurants, the firm created what designers call "the ultimate luggage for the Free Jazz trip." The suitcase contained all the essentials: a disposable camera, postcards, a CD of classic jazz, a plane ticket, and a travel guide to Brazil. Unfortunately, or fortunately, the display created such a stir that people assumed wrongly that these items were free, and many displays were routinely emptied. This caused headaches for the replacement crew but signaled clearly that people noticed the promotion.

Extending an Invitation

"Make it personal. Invitations that look like direct mail go in the trash. Don't use mailing labels or a postage meter. Run your envelopes directly through the printer. Use colored envelopes and an actual picture postage stamp. All of these things will make recipients feel special and will add to their opinion of whether or not the event is worth attending."
—Morgan Shorey, The List®

Invitations tick off the milestones of our lives. Cute and cuddly invitations celebrate early birthdays. Invitations with plenty of pomp and circumstance bring friends and relatives to graduation celebrations. Multipart invitations in whites, ivories, and pastels announce impending nuptials.

As we mature, so do the invitations that we extend. They express individual personality, whether on a small or grand scale. Invitations can be bought by the bundle or custom printed. They can be simple and handwritten or elegantly embossed, engraved, and foil stamped. They can arrive on traditional white card stock, exotic imported papers, or even newsprint.

Like invitations to life's monumental events, invitations of a personal nature exist largely to disseminate information. They don't have to work overly hard to persuade grandparents, mom and dad, aunts and uncles, and siblings to attend. It isn't easy for family members to wiggle out of an RSVP to a must-attend event.

When invitations enter the business arena, the objective changes markedly. To motivate business colleagues, clients, vendors, and prospects to consider your invitation to a must-attend event, it must not only provide the date, time, and location, but also must provide reasons for their attendance.

The host may know the invitees only professionally, if at all. Because a relationship may not exist, there is no obligation to attend. An invitation might very well provide a first impression, so it should reveal as much about the company or individual as possible. That first impression also should persuade the recipient to attend the event.

The invitation—sometimes as small as three inches square—must pack persuasive power that convinces the recipient to break from comfortable routine to attend, requiring considerably more effort than, say, writing a check. A business event intrudes on work schedules, cuts short personal time, and requires special arrangements, such as hiring a sitter.

An invitation is a selling tool, but don't forget that invitations should be inviting and captivating. We offer our hospitality when we extend an invitation. If the event mood is casual, the invitation should reflect that. If it's formal, the invitation should not only say black-tie, but also should look the part.

Creative graphics, innovative printing techniques, unusual paper stocks, and clever copywriting can build anticipation and set the tone. If these elements are all brought together successfully, the invitation not only will assure good attendance, but will also be a memento of the event long after the speeches are over, the dishes are cleared, and the decorations taken down.

Some of the invitations included in this collection are avant-garde; others are experimental or traditional. They range from simple to elaborate. In each case, the answer to the traditional request, répondez s'il vous plaît, was a resounding "Yes!"

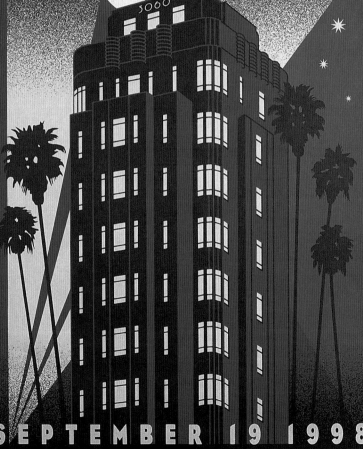

3OSIXTY END-OF-SUMMER PARTY INVITATION

Design Firm: 30sixty design, inc.
Art Director/Designer/Illustrator: Pär Larsson
Copywriter: Hillel Wasserman
Client: 30sixty design, inc.
Printer: D.I.S.C.

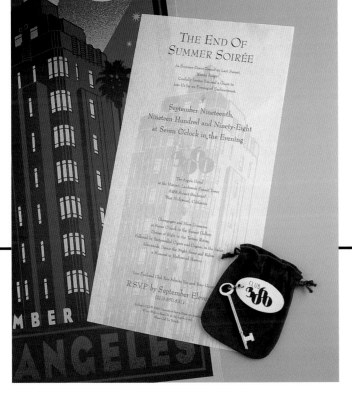

Paper Stock: Poster—Vicksburg Starwhite Tiara 65 lb. vellum cover, Invitation—Glama Natural, Parchment White 29 lb.
Printing: 5 spot colors, offset
Print Quantity: 200

It is not surprising that 75 percent of the clients and friends invited to 30sixty design's end–of–summer bash attended. Pär Larsson designed this stunning invitation as an art deco poster to capture the essence of 1930s Hollywood while featuring the historic Argyle Hotel where the party was held. The poster is coupled with a blue velvet pouch containing a weighty silver key that provides entrée to the party. The invitation not only motivated recipients to attend, but also proved to be a keeper that hung around many offices long after the event.

Design Firm: Sagmeister Inc.
Art Director: Stefan Sagmeister
Designers: Hjalti Karlsson, Martin Woodtli
Photographer: Tom Schierlift
Client: Anni Kuan Design
Printer: Jae Kim Printing Company

Paper Stock: Newsprint
Printing: 1 color, web
Print Quantity: 750

"Phenomenal!" That's how Stefan Sagmeister describes the results of this direct-mail piece designed to increase awareness for Anni Kuan Design while inviting recipients to visit the fashion designer at an upcoming trade show. Who could ignore this oversized invitation? Moreover, who would guess that it was produced on a shoestring budget? According to Sagmeister, the budget had room only for printing a postcard. But as soon as Sagmeister hooked up with an inexpensive newspaper printer who could run the entire job for less than $500, the entire concept took flight.

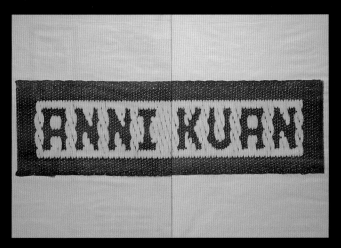

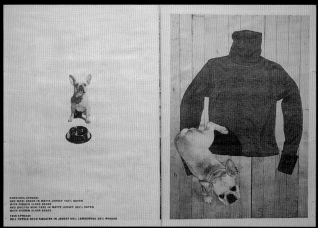

Wire hangers added an additional two cents apiece to the job, while the corrugated board added twelve pennies to the project. The client purchased a shrink-wrap machine for $500 and hired a student to assemble all the parts. The unusual size and unusual subject matter—celebrating New York laundromats—proved to be a real attention getter that didn't merely request a response, but demanded one.

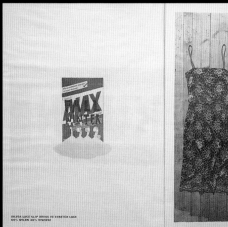

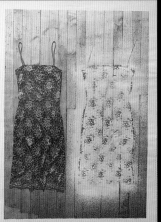

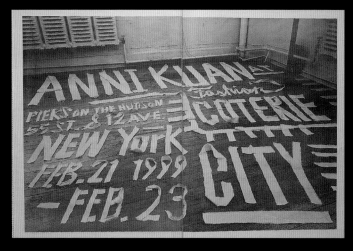

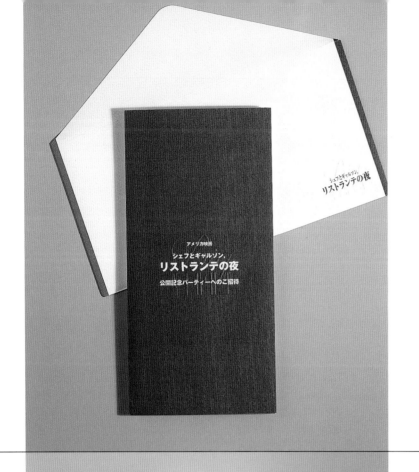

BIG NIGHT INVITATION

Design Firm: Kenzo Izutani Office Corporation
Art Director: Kenzo Izutani
Designers: Kenzo Izutani, Aki Hirai
Copywriter: Goro Aoyama
Client: Producer Associates Co., Ltd.
Printer: Nimura Printing

Paper Stock: Pamis White
Printing: 3 colors, offset
Print Quantity: 500

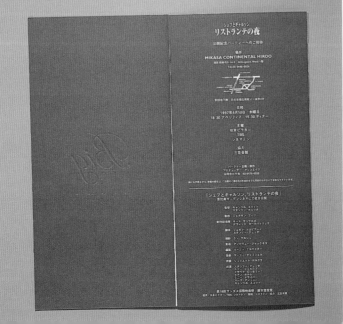

This invitation to a dinner party and cinema "Big Night" preview is elegant and sophisticated. Designers' choice of a textured, uncoated paper stock; rich color palette of port, forest green, and ivory; and embossed cover all combine to convey that this is a special event. The copy is streamlined. The evening's menu, overview of "Big Night," and the incidentals, such as a map to the location, are all treated with unobtrusive simplicity.

Of special note is the unique combination of cultures exhibited in this invitation. The event was held in Japan, where the invitation was designed. The cinema event was uniquely American, but the content was Italian—hence the use of graphics evocative of an Italian theme.

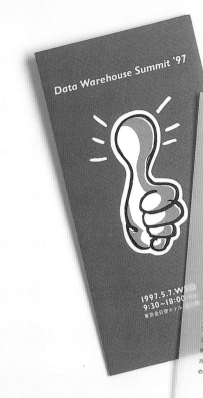

SUN MICROSYSTEMS
DATA WAREHOUSE SUMMIT INVITATION

Design Firm: Kenzo Izutani Office Corporation
Art Director: Kenzo Izutani
Designers: Kenzo Izutani, Aki Hirai
Illustrator: Aki Hirai
Copywriter: Yoshinori Saijyou
Client: Sun Microsystems K.K.
Printer: Kyuryudo Printing

Paper Stock: Sable Snow White
Printing: 4 colors, offset
Print Quantity: 10,000

Kenzo Izutani managed to pack a lot of information about this seminar into a very tidy invitation. A translucent insert provides background on the event, but the heart of the invitation is the trifold brochure featuring a die-cut cover. The inside itemizes the seminar's entire agenda—including three extensive breakout sessions. Treated differently, this much information might overload the reader, but the organized layout and choice of color coding please the eye.

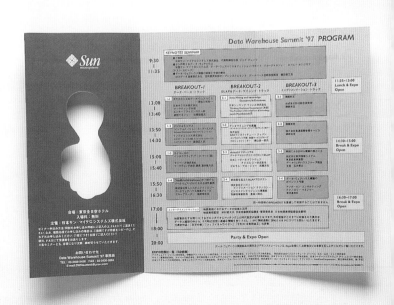

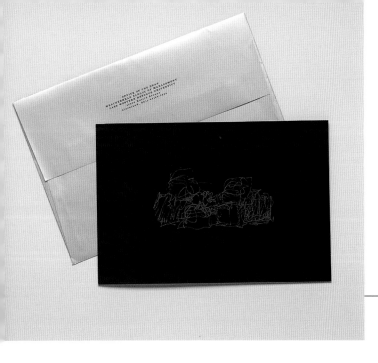

GROUNDBREAKING INVITATION

Design Firm: Nesnadny + Schwartz
Art Director: Mark Schwartz
Designers: Timothy Lachina, Cindy Lowrey, Stacie Ross, Gregory Oznowich
Photographer: Frank O. Gehry & Associates
Copywriter: Ellen Machan
Client: Case Western Reserve University Weatherhead School of Management

Paper Stock: Vintage 80 lb. text
Printing: 6 colors, sheetfed
Print Quantity: 2000

The invitation for the groundbreaking of architect Frank Gehry's vision of the Case Western Reserve University Weatherhead School of Management reflects the building's progressive combination of form and function and its use of unexpected materials and styles. The first impression comes from the envelope—printed in steely metallic ink. The design team used the architect's original thumbnail sketch as the focal cover graphic, complementing nine views of the building model. In total, the images resemble abstract art and illustrate the transition between the architect's vision and reality. Portions of the cover sketch are enlarged and repeated on the inside spread where the black and violet hues are equally dynamic.

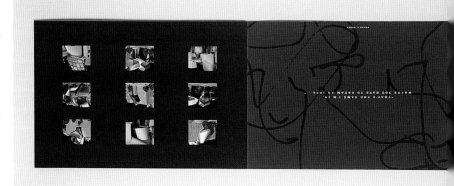

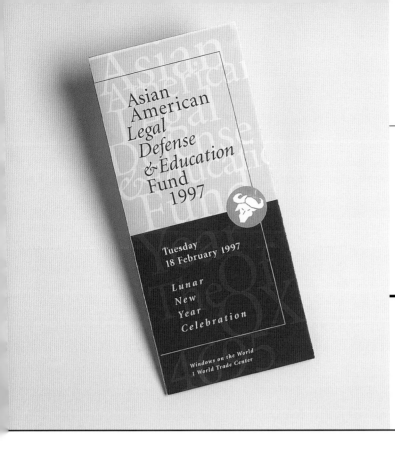

Design Firm: Designation Inc.
Designer/Illustrator: Mike Quon
Copywriter: Margaret Fung
Client: Asian American Legal Defense & Education Fund
Printer: Skilltech Global Printers

Paper Stock: Strathmore wove 80 lb. cover
Printing: 2 colors, offset
Print Quantity: 3000

This invitation is remarkable for the number of reasons it uses to persuade the recipient to attend the annual fundraiser. The five-panel brochure is not constructed as a traditional invitation, but packs in all the information one would need to prompt an RSVP. It provides an overview of the organization and the evening's program, three short biographies of the honorees, and an extensive list of thank you's and acknowledgments. The pleasing color palette and educational value of this piece give it additional impact—making it work despite its low budget.

ASIAN AMERICAN LEGAL DEFENSE AND EDUCATION FUND INVITATION 1998

Design Firm: Designation Inc.
Designer/Illustrator: Mike Quon
Copywriter: Margaret Fung
Client: Asian American Legal Defense & Education Fund
Printer: Skilltech Global Printers

Paper Stock: Strathmore 80 lb. wove cover
Printing: 2 colors, offset
Print Quantity: 3000

The 1998 version of Designation's annual fundraising dinner invitation for the Asian American Legal Defense and Education Fund has three things in common with its predecessor: low budget, abundant use of color, and a common theme that focuses on the Chinese zodiac. Beyond that, these invitations are startlingly different. Managing to keep annual invitations fresh yet cohesive from year to year is not an easy task, but Designation's Mike Quon succeeds in doing just that. Many elements remain consistent. Yet the design is so fresh that one can't help but believe that recipients anticipate this invitation if only to see what the invitation will look like each year.

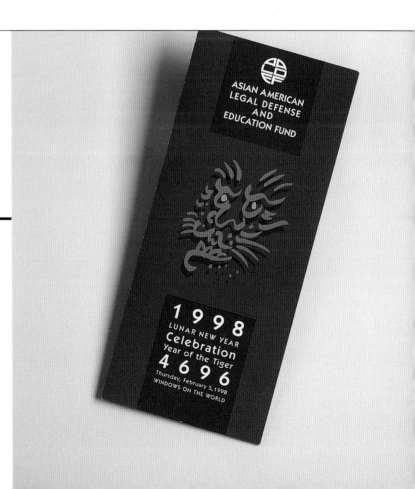

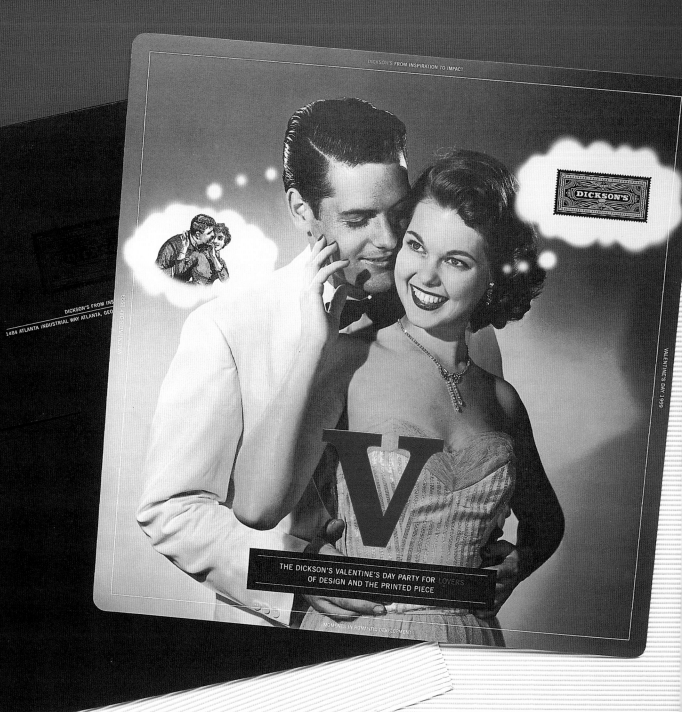

Design Firm: Vista, Inc.
Art Directors: Brant Day, Steve Beshara
Designer/Copywriter: Brant Day
Client: Dickson's, Inc.
Printer: Dickson's, Inc.

(This page) Paper Stock: Teaser Card—Mohawk Navajo Smooth Brilliant White 80 lb. cover, Label—Mohawk Navajo Smooth Brilliant White text
Printing: 3 over 3, foil-stamped and embossed, offset
Print Quantity: 300

(Opposite) Paper Stock: Envelope—French Speckletone black 80 lb. cover, Poster—Mohawk Navajo Smooth Brilliant White double-thick 130 lb. cover, Invitation—Mohawk Navajo Smooth Brilliant White 80 lb. cover
Printing: 3 over 3, foil-stamped and embossed, offset
Print Quantity: 300

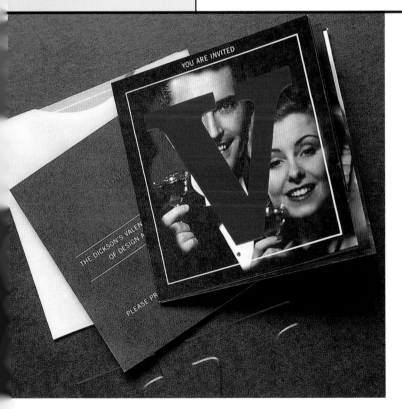

Dickson's, Inc., an Atlanta specialty printer, created plenty of talk in the design community when this single teaser card was mailed (this page top). The only information apparent from the retro photograph was that Dickson's was planning some sort of celebration. In short, recipients knew only that V-Day was coming.

The reverse of the card features a label with the copy "Save the Date," allowing recipients to do just that—peel off the sticker and place it in their calendars as a not–too–subtle reminder of the date, time, and location of the mystery event.

This piece, like many of those to follow, was printed in three colors. The black-and-white color scheme contrasts sharply to a vivid, red, foil-stamped letter V, the cornerstone of the design. The Dickson's logo also is foil-stamped.

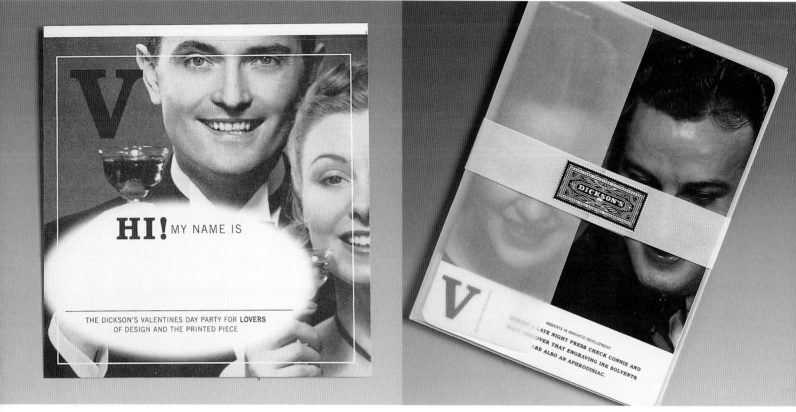

Nametag

Notecards above and opposite

Dickson's eased the mystery by delivering the actual invitation—it mailed 100 and hand-delivered 200—but the buzz only increased.

The elegant, oversized envelope holds a poster on double-thick cover stock, announcing Dickson's Valentine's Day party for "lovers of design and the printed piece." A subhead introduces the theme, Moments in Romantic Development, which is carried through the matching party pieces (page 40).

The actual invitation appears on the reverse, slipped into a translucent pocket glued onto the back of the poster. As a study in contrasts, the comparison of the pieces couldn't be more dramatic. The oversized envelope and poster measure nearly 16" by 16" (41 cm x 41 cm) compared with the relatively minute 3" by 3¼" (8.5 cm x 8.5 cm) ten-page booklet with all the logistical details. Tucked inside the booklet is yet another element, an admit-one card with directions to the party location detailed on the reverse (page 41 bottom).

Upon arrival, partygoers were given a name tag that matched the invitation (above left). As a special thank you and remembrance of the event, Dickson's gave everyone a set of four belly-banded note cards and envelopes featuring Moments in Romantic Development, humorous scenarios in romancing the creative process that any graphic designer could appreciate (above right and opposite).

When all the food was eaten and everyone had gone home, Gary Dickson, president of Dickson's, Inc., surveyed the results. "The response was overwhelming. We printed 300 invitations and had 275 attendees. There was plenty of buzz for months after the party plus calls from designers we hadn't worked with before."

Paper Stock: Nametag—MACtac StarLiner Blinding White Cards—Mohawk Navajo Smooth Brilliant White 80 lb. cover
Envelopes and belly-band—Glama Neutral Translucent 29 lb.
Print Quantity: 300

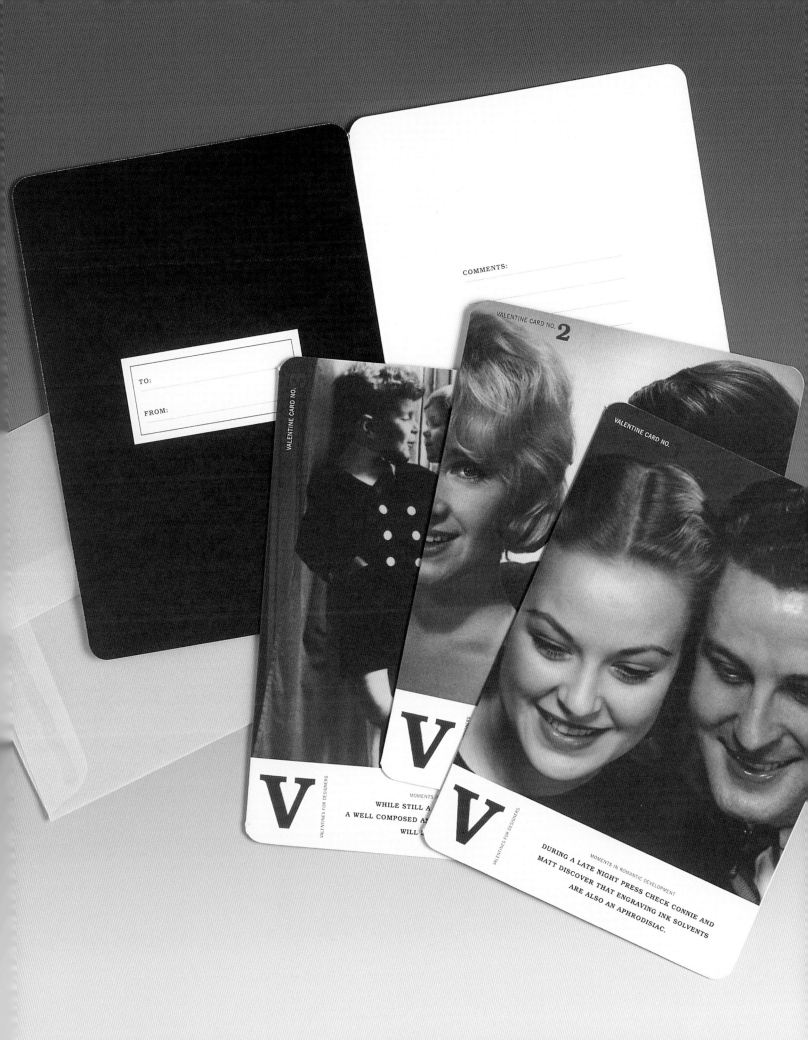

TO:

FROM:

COMMENTS:

VALENTINE CARD NO. **2**

VALENTINE CARD NO.

VALENTINE CARD NO.

V

VALENTINES FOR DESIGNERS

MOMENTS IN
WHILE STILL A
A WELL COMPOSED AN
WILL

V

VALENTINES FOR DESIGNERS

MOMENTS IN ROMANTIC DEVELOPMENT
DURING A LATE NIGHT PRESS CHECK CONNIE AND
MATT DISCOVER THAT ENGRAVING INK SOLVENTS
ARE ALSO AN APHRODISIAC.

ARTHUR ANDERSEN MASTERS TOURNAMENT INVITATION

Design Firm: i. wood creative works
Art Director/Designer: Ilia Wood
Client: Arthur Andersen
Printer: Dickson's, Inc.

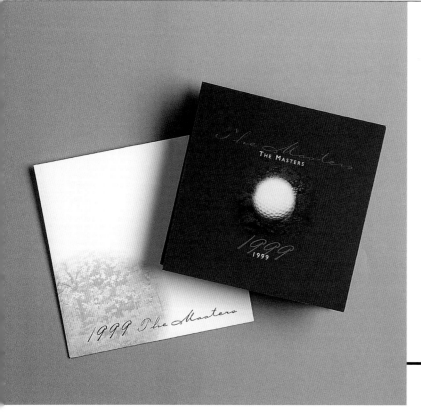

Paper Stock: Mohawk Superfine Ultrawhite Smooth 130 lb. cover
Printing: Invitation—4-color process,
offset and die-cut with specialty scoring, Envelope—1 color
Print Quantity: 250

The Masters golf tournament has its own intrinsic value, so to promote the private party hosted by Arthur Andersen that followed the event, the year became the focus of the invitation. It is printed on a heavy stock to allow for the distinctive die-cutting and specialty scoring, all of which make this invitation stand out—literally. The copy also stands out with its script typeface echoed in a clean sans serif face. Together, the graphics, intricate cutout, and copy sent a successful message, earning an 80 percent response rate.

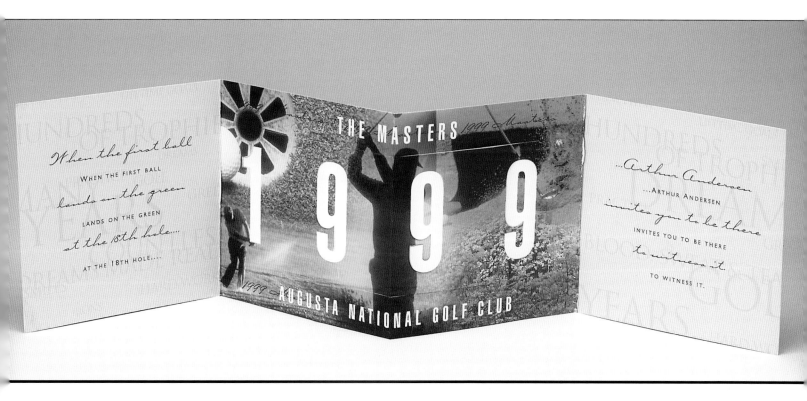

When the first ball
WHEN THE FIRST BALL
lands on the green
LANDS ON THE GREEN
at the 18th hole....
AT THE 18TH HOLE....

THE MASTERS
1999
1999 — AUGUSTA NATIONAL GOLF CLUB

...Arthur Andersen
...ARTHUR ANDERSEN
invites you to be there
INVITES YOU TO BE THERE
to witness it.
TO WITNESS IT.

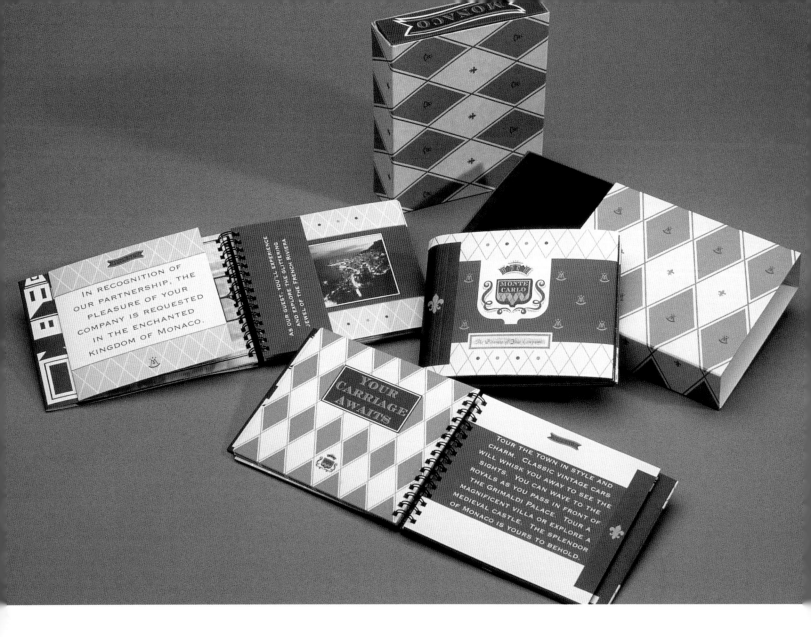

GALILEO INTERNATIONAL INVITATION

Design Firm: Sayles Graphic Design
Art Director/Designer/Illustrator: John Sayles
Copywriter: Wendy Lyons
Client: Galileo International

Paper Stock: Graphika Cream Smooth
Printing: 4-color process, offset
Print Quantity: 75

When an invitation achieves a 100 percent response rate, it must be doing something right. Galileo International, a travel–management company, called upon Sayles Graphic Design to produce an invitation to a special four-day getaway to Monaco that targeted very special customers. In keeping with the upscale nature of the event, the invitation arrived in a box decorated with a fleur-de-lis and monogram pattern. The pattern was repeated on the cover of the wire-bound brochure inside, along with a crest design developed by John Sayles especially for the event. For added interest, photos and maps of the region, hand-rendered graphics on pages of various lengths, and French phrases were added to create atmosphere. Not surprisingly, every one of the seventy-five people invited responded with a "Yes!"

BOMBARDIER AEROSPACE NBAA INVITATION

Design Firm: Greteman Group
Art Directors/Designers: Sonia Greteman, James Strange
Illustrator: Sonia Greteman
Client: Bombardier Aerospace
Printer: Donlevy Lithography

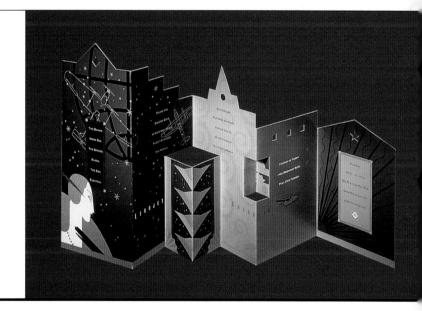

Paper Stock: Karma Lustro dull
Printing: 4 colors plus 2 varnishes, offset
Print Quantity: 5000

The unusual die-cut of an art-deco skyline differentiates this three-dimensional invitation from the ordinary; attendance exceeded all expectations. The goal was to position Bombardier's event as the place to be. The event was held at Florida's world-famous Fantasy of Flight. This setting provided the visual theme. Graphics and copy reminiscent of the 1930s reinforced it.

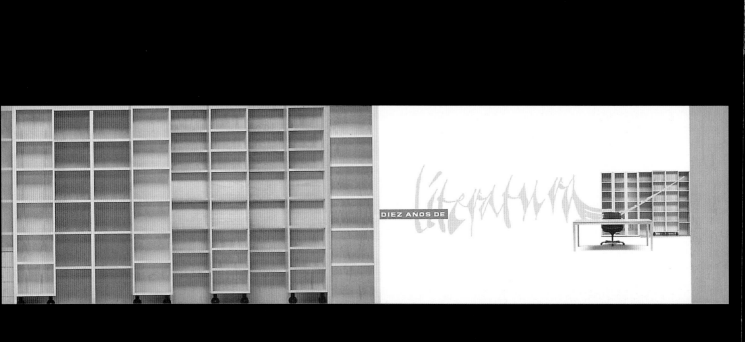

DIEZ AÑOS DE *literatura*

Design Firm: Pepe Gimeno—Proyecto Gráfico
Designer: Pepe Gimeno
Client: Punt Mobles
Printer: Sancho Artes Gráficasa

Paper Stock: Torras Papel Invercote Graphique X, 170 y 390 g.
Printing: 4 colors, offset
Print Quantity: 2000

Literatura, a line of shelving furniture, commemorated the tenth anniversary of its launch with this interactive mailer. It invited recipients to attend a special exhibit that featured the streamlined, mobile units. The card/invitation mimics the furniture's movements—when the recipient displaces the portion of the unit on wheels, the text appears and cleverly demonstrates the product. The card was mailed in a slim envelope; together, they proved to be as sleek as the product they featured.

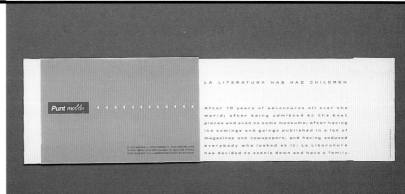

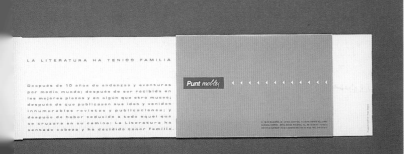

HWS HORSE THERAPY INVITATION

Design Firm: Greteman Group
Art Directors/Designers: Sonia Greteman, James Strange
Copywriter: Raleigh Drennon
Client: HWS Horse Therapy
Printer: PrintMaster

Paper Stock: Chipboard
Printing: 2 colors, offset
Print Quantity: 5000

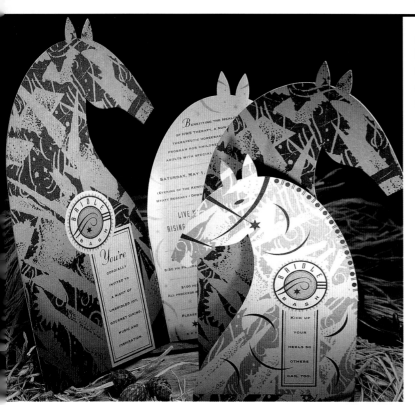

A gala fundraising event for a therapeutic horseback-riding program to benefit the physically impaired required an invitation that would seize attention and ultimately reap donations. The budget wasn't generous. To keep costs low, designers used inexpensive chipboard to maximum effect. The chipboard enhances the rustic design but does not detract from the center-stage horse graphic.

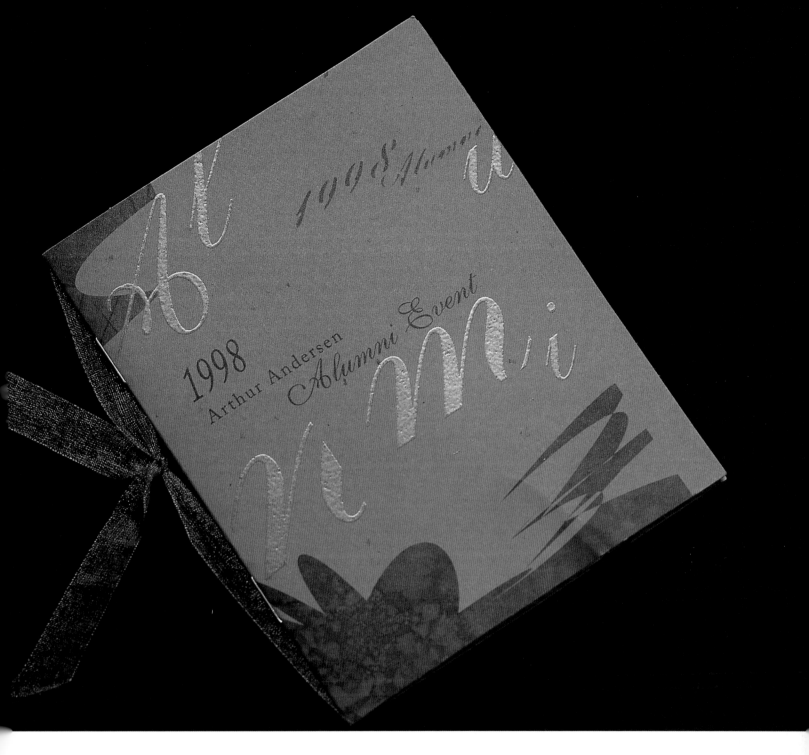

ARTHUR ANDERSEN COMPANY
ALUMNI INVITATION

Design Firm: Arthur Andersen Company In-house
Art Director/Designer: Jenny Lucas
Client: Arthur Andersen Company
Printer: Dickson's, Inc.

Paper Stock: Celebration Pumpkin Pie 80 lb. cover
Printing: 4 color, plus thermography

This invitation's diminutive size, autumnal color palette, and gossamer ribbon lend an air of sophistication and elegance. The subtle thermography on the cover gives it a tactile quality, while the unusual mix-and-match combination of typestyles also differentiates it from other similar invitations.

ROCKWELL COLLINS FARNBOROUGH INVITATION

Design Firm: Greteman Group
Art Directors: Sonia Greteman, James Strange
Designer: James Strange
Copywriter: Deanna Harms
Client: Rockwell Collins
Printer: PrintMaster

Paper Stock: Warren Lustro Dull, Beckett Expression
Printing: 4 colors, offset
Print Quantity: 5000

Rockwell Collins increased traffic at the Farnborough Air Show with this invitation. The company wanted to reflect a high-tech navigational image, so the designers chose graphics and a bold color palette to do just that. For additional impact, they added a simple triangular die-cut. This enhances the invitation's cover when closed and draws attention to a more intricate die-cut when opened.

FIONS PARTY INVITATION

Design Firm: SuZen Creations
Art Director/Designer/Photographer: SuZen
Copywriters: Anita Baron, Nancy Barrie-Chivian
Client: Fions
Printer: 434 Copy Center

Paper Stock: 80 lb. uncoated
Printing: 1 color, photocopy
Print Quantity: 500

It doesn't always have to cost a fortune to create an invitation that gets results. This invitation is so direct and communicates its message so successfully that it is no less effective despite being photocopied in one-color on an uncoated tan paper stock. This no-frills approach proved to be a powerful combination, motivating more than 100 people to attend the event.

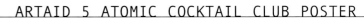

Design Firm: Greteman Group
Art Directors/Designers: Sonia Greteman, James Strange
Copywriter: Todd Gimlin
Client: ConnectCare
Printer: PrintMaster

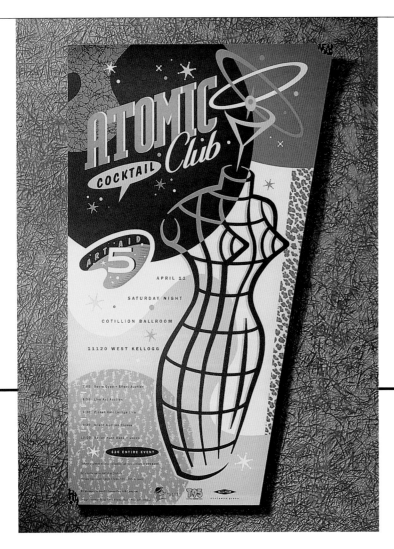

Paper Stock: Crosspoint Brights Canary cover
Printing: 4 colors, offset
Print Quantity: 5000

Everyone involved with the creation of this poster donated their services to help announce a major fundraiser for ConnectCare, a program for people with AIDS or who are HIV positive. The poster strays from the usual soft color palette associated with health-care fundraisers. It makes its mark with bold, funky graphics, invigorating colors, and a double-entendre title, "Atomic Cocktail Club." Supported with other marketing materials, this poster helped the event to break all previous records—more people attended and more money was raised than ever before.

Design Firm: Lowercase, Inc.
Art Director/Designer: Tim Bruce
Copywriter: Michael Halberstam
Client: Writers' Theatre Chicago
Printer: Dupligraphics

Paper Stock: Mohawk Superfine 80 lb. cover
Printing: 3 PMS colors and varnish, offset
Print Quantity: 3000

Laissez les bon temps roulez! The French theme of this event is dramatically illustrated by the invitation's tri-tone color palette that is played out on five invitational cards. Each card has its own distinct message, which leads up to the next in succession. The invitation is lighthearted and virtually guarantees a good time.

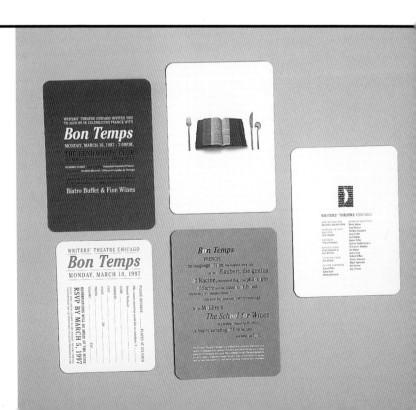

HOULIHAN LOKEY HOWARD & ZUKIN
INVITATION

Design Firm: Julia Tam Design
Art Director/Designer: Julia Tam
Illustrator: Ken Barton
Copywriter: Dennis Moore
Client: Houlihan Lokey Howard & Zukin
Printer: Crown Graphics

Printing: 2-color foil-stamped plus 1 color, sheetfed
Print Quantity: 1000

The rich, textural quality of this invitation to an event at The Folger Shakespeare Library is unmistakable. This invitation so perfectly marries the event's theme with its setting that it generated plenty of anticipation among recipients, who could tell that the event would be special long before they arrived.

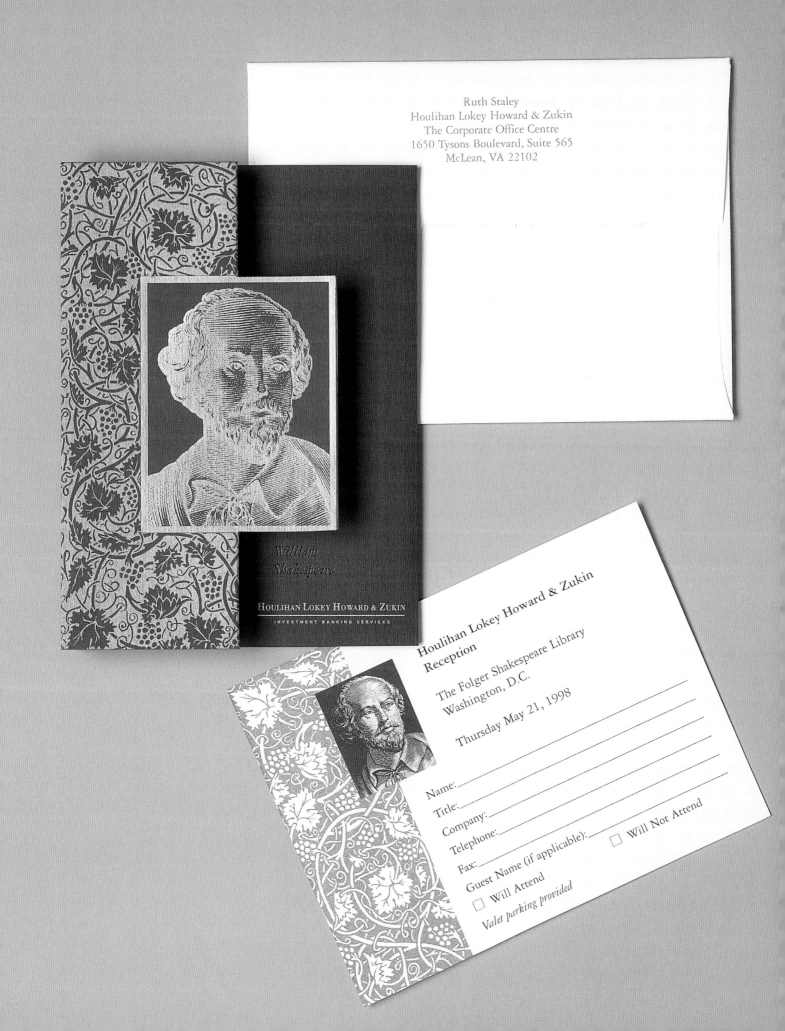

Ruth Staley
Houlihan Lokey Howard & Zukin
The Corporate Office Centre
1650 Tysons Boulevard, Suite 565
McLean, VA 22102

William Shakespeare

HOULIHAN LOKEY HOWARD & ZUKIN
INVESTMENT BANKING SERVICES

Houlihan Lokey Howard & Zukin
Reception

The Folger Shakespeare Library
Washington, D.C.

Thursday May 21, 1998

Name:_____
Title:_____
Company:_____
Telephone:_____
Fax:_____ ☐ Will Not Attend
Guest Name (if applicable):_____
☐ Will Attend
Valet parking provided

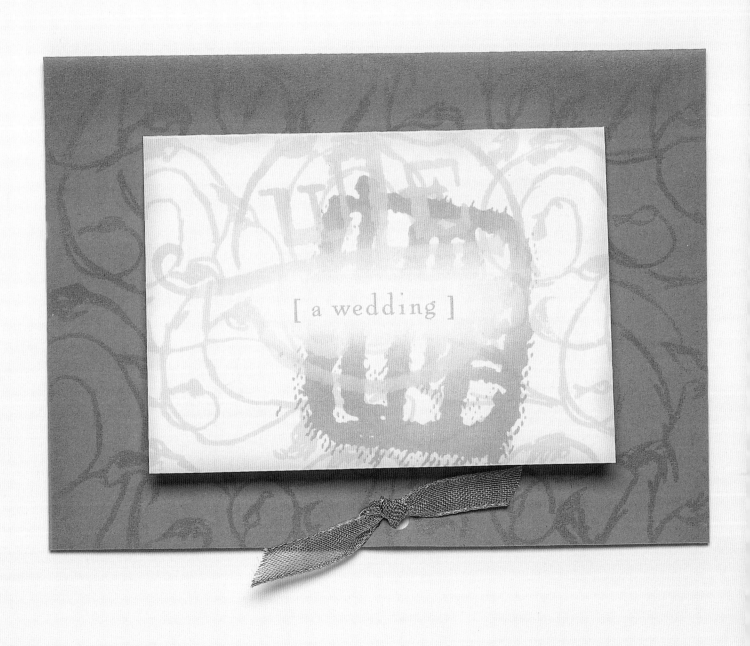

[a wedding]

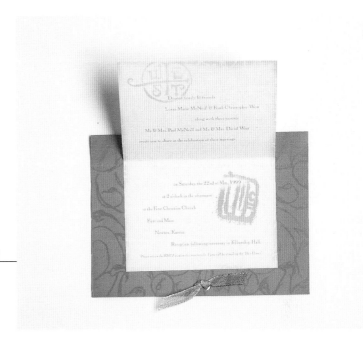

CHRIS WEST AND LORNA McNIEL
WEDDING INVITATION

Design Firm: Love Packaging Group
Art Director: Chris West
Designers/Illustrators/Copywriters: Chris West, Lorna McNiel
Client: Chris West and Lorna McNiel
Printer: In-house

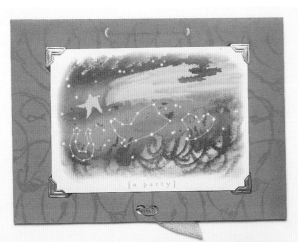

Paper Stock: Springhill Ivory 80 lb., 60 lb. kraft, vellum envelope
Printing: 4-color process, Tecktronic 780
Print Quantity: 300

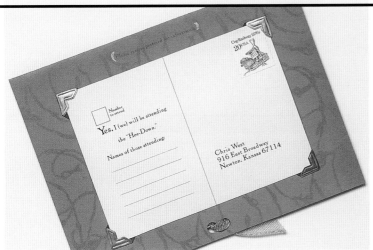

The whimsical nature of this wedding invitation—created by two designers—almost assures that all will have a good time. One side includes traditional wedding information, while the reverse of the card provides the reply in the form of a post-card, secured to the wedding invitation with gold photo corners. When recipients remove the reply card, they expose particulars of the wedding reception. Printing in-house and hand assembly all helped keep costs down without sacrificing impact. Of the 300 people invited, 250 attended the celebration.

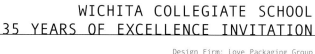

WICHITA COLLEGIATE SCHOOL
35 YEARS OF EXCELLENCE INVITATION

Design Firm: Love Packaging Group
Art Director: Chris West
Designer/Illustrator: Dustin Commer
Photographer: Jack Jacobs
Client: Wichita Collegiate School
Printer: Quality Printing

Paper Stock: 80 lb. stock white
Printing: 2 colors, offset
Print Quantity: 2000

More than 50 percent of those targeted attended this event commemorating Wichita Collegiate School's thirty-five years of excellence. The response rate was overwhelmingly positive considering that the invitation, mailed across the country, required a considerable number of out-of-towners to travel to Kansas. The invitation's distinctive folded envelope and the inclusion of a button with matching graphics combined to create unique appeal.

BELYEA INVITATION

Design Firm: Belyea
Art Director: Paricia Belyea
Designer: Ron Lars Hansen
Photographer: Rosanne Olson
Copywriter: Liz Holland
Calligraphy: Jocelyn Curry
Client: Belyea
Printer: ColorGraphics

Paper Stock: Graphika Cream Smooth Finish 80 lb. cover
Printing: 4-color process, semifluorescent inks, sheetfed
Print Quantity: 500

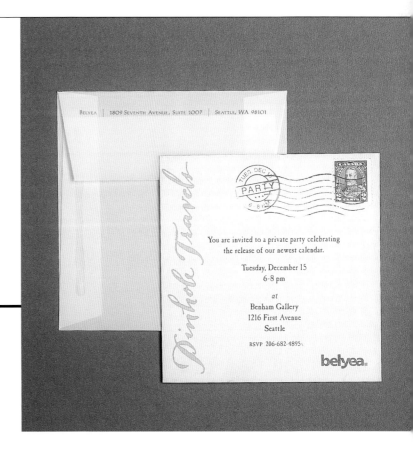

Every year, Belyea distributes an eagerly anticipated calendar. To commemorate its newest edition, Belyea invited clients and prospects to a rollout party. The invitation was printed along with the calendar and used many of the same images. The design is simple and possesses an old-world charm in its choice of type and imagery, particularly the vintage two-cent stamp. In all, the invitation tells the recipient that the party, like the upcoming calendar, will be special.

Design Firm: X Design Company
Art Director/Illustrator: Alex Valderrama
Designer: Kay Flierl
Client: Richtman Printing
Printer: Richtman Printing

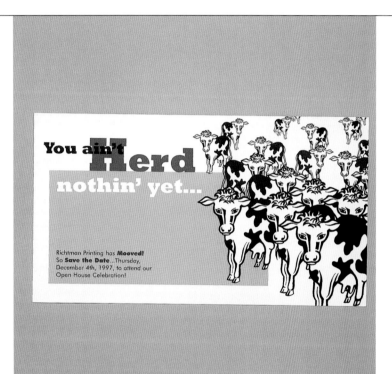

Paper Stock: Centura 80 lb. cover
Printing: 4-color process, sheetfed
Print Quantity: 1200

To motivate graphic designers and art directors to attend this printer's grand opening in a new location, the design team at the X Design Company knew it needed a strong concept with equally powerful illustrations. The result was an attention-getting cowhide graphic. This prompted the use of numerous puns and playful copy, including "Hay," "We've mooved," and "You ain't herd nothin' yet." The oversized save-the-date postcard was mailed first, and the matching brochure followed. Nearly 250 designers and directors turned out for the event.

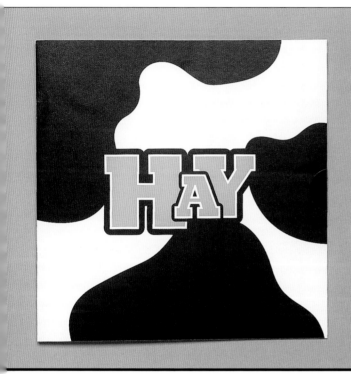

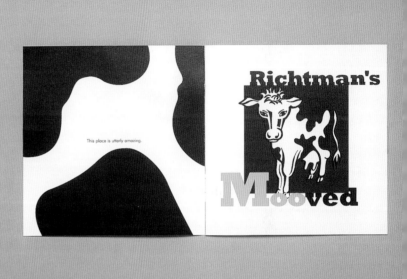

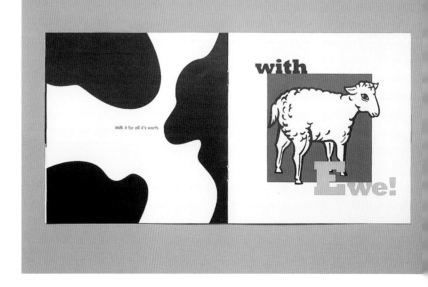

Generating Leads
and Inquiries

"Too often, people get discouraged after just four or five contacts, or worse, they run out of stuff to send. A successful direct-response effort requires eight to twelve contacts, including a mailer, a call, an in-person meeting, another mailer, and so on. They key is having six to twelve months of material on hand, ready for mailing—even when business is good."
—Morgan Shorey, The List®

Like prospecting for gold, prospecting for clients is a hit-and-miss business. Sometimes the payoff is big, but more likely, one must sift through a lot of sand to find gold. Prospecting requires considerable patience—sometimes up to a year or more to transition a prospect into a client—frustration, more often than increased sales, often results.

Skilled marketers know that to avoid frustration they must orchestrate a consistent program that increases momentum with each contact. Regular contact with prospects ensures that they will remember the message when awareness turns into need. Experts recommend monthly contact to insure that a product or service is at the right place at the right time. But one only has to multiply twelve months by the number of contacts on a mailing list, and then multiply that total by a minimum of thirty-three cents to know this can be an expensive proposition in mailing costs alone. So how does one successfully mine for leads and stay within the budget at the same time?

The secret is to deftly tailor a lead-generating campaign that employs various approaches, mixed and matched to achieve the marketing objectives cost effectively without sacrificing impact. This chapter features a myriad of such examples. The print quantities on these pieces range from voluminous mass-marketing efforts to small, select groups of recipients. Some pieces are elaborate brochures and CD-ROMs. Others are as simple as a two-color postcard. One is no less effective than the other when the design is carefully tailored to its market.

The goal when generating inquiries is to create an impression, hopefully a memorable and positive one. No one expects these pieces alone to generate business. They are but one element in a comprehensive direct-response effort. One piece, followed by another in a month, followed by a phone call or in-person contact, can change the recipient from a lead to a prospect to a client.

BOELTS BROS. ASSOCIATES NEWSLETTER

Design Firm: Boelts Bros. Associates
Art Directors: Kerry Stratford, Jackson Boelts, Eric Boelts
Designer/Illustrator: Elicia Taylor
Copywriter: Boelts Bros. Associates
Client: Boelts Bros. Associates
Printer: Hollis Digital

Paper Stock: 12 pt. card stock
Printing: 4 colors, offset
Print Quantity: 400

Company newsletters, designed to toot the firm's horn, usually are immediate targets for the circular file because they are self-serving and tedious for busy clients and prospects to read. Obviously, Boelts Bros. was well aware of this pitfall and took steps to avoid it. This slim newsletter provides the skinny on Boelts Bros. in the summer of '99. Each of the eight panels has a short story to tell about a new Boelts staff member. The blurbs average only about fifty words—boastful yet interesting and short enough to read without boredom. The color palette is energizing, too. The newsletter doesn't request immediate action. But as part of an ongoing mailing campaign, it keeps Boelts Bros. top of mind, the first step in generating interest and inquiries.

UNIVERSITY OF SOUTHERN CALIFORNIA
HEALTH PROMOTION AND DISEASE
PREVENTION STUDIES BROCHURE

Design Firm: Vrontikis Design Office
Art Director: Petrula Vrontikis
Designer: Susan Carter
Photographer: Stephen Heller
Copywriter: Elahe Nezami
Client: University of Southern California (USC)
Printer: Donahue Printing

Paper Stock: Potlatch Vintage Velvet
Printing: 4-color process plus varnish, sheetfed
Print Quantity: 10,000

This brochure doesn't overwhelm. Instead, it presents a succinct overview of the University's Health Promotion and Disease Prevention Studies program and life at USC. The goal: by conveying six key points to recipients and potential students, motivate them to request additional information by sending in the reply card. Each point is numbered—making it extremely easy for the reader to weigh the facts and make a decision. Even the reply card is clean and easy to follow. Such ease and convenience persuade the recipient to say "Yes."

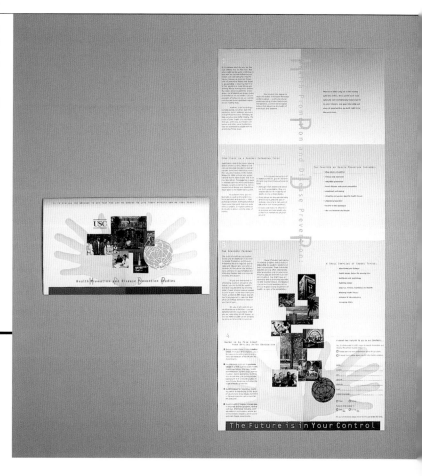

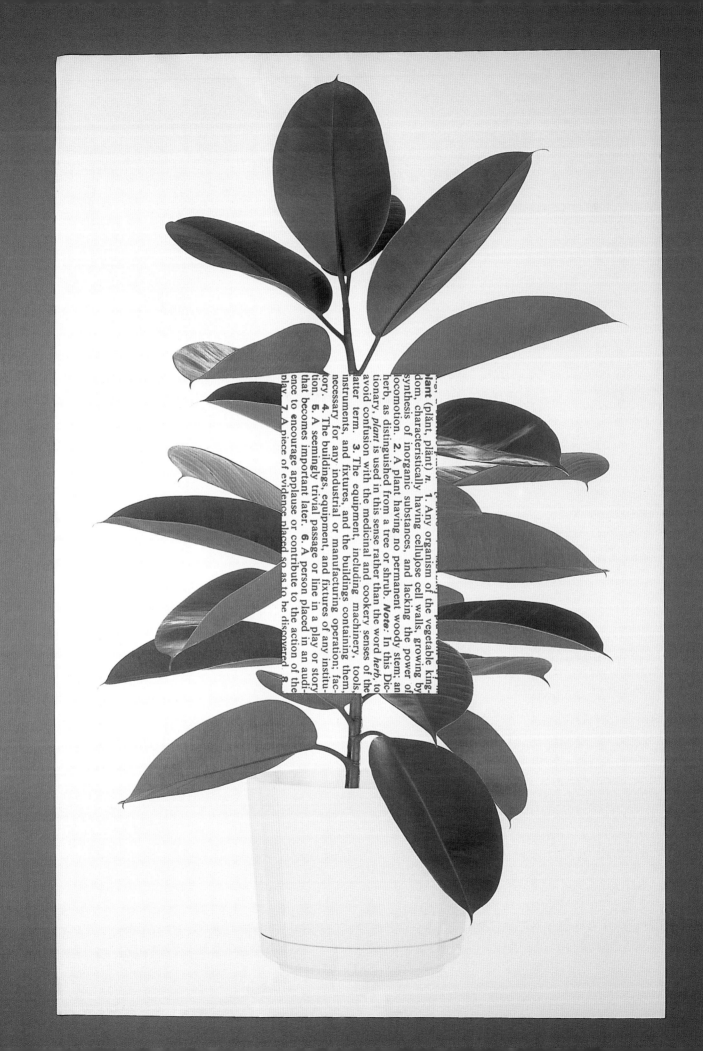

plant (plănt, plänt) *n.* **1.** Any organism of the vegetable kingdom, characteristically having cellulose cell walls, growing by synthesis of inorganic substances, and lacking the power of locomotion. **2.** A plant having no permanent woody stem; an herb, as distinguished from a tree or shrub. *Note:* In this Dictionary, *plant* is used in this sense rather than the word *herb*, to avoid confusion with the medicinal and cookery senses of the latter term. **3.** The equipment, including machinery, tools, instruments, and fixtures, and the buildings containing them, necessary for any industrial or manufacturing operation; factory. **4.** The buildings, equipment, and fixtures of any institution. **5.** A seemingly trivial passage or line in a play or story that becomes important later. **6.** A person placed in an audience to encourage applause or contribute to the action of the play. **7.** A piece of evidence placed so as to be discovered. **8.**

The Plant

DOLAN WOHLERS TERWILLIGER BROCHURE

Design Firm: Addison
Art Directors: David Kohler, Dan Koh
Designer: David Kohler
Illustrator: Karen Kluglein
Photographers: Jody Dole, William Vázquez
Copywriters: David Kohler, lyrics from "High Hopes" by Sammy Kahn
Client: Dolan Wohlers Terwilliger

Paper Stock: Monadnock Astrolite 100 lb. cover
Printing: 4-color process, a special black, and dry trap varnish; sheetfed
Print Quantity: 5000

Addison's goal was to create a lasting impression and to increase visibility for its client with the announcement of Dolan Wolhers Terwilliger's new printing facility. The firm succeeded with this enormous brochure that more closely resembles a set of four posters mailed as one. The design plays off the word *plant,* a clever way to give visual appeal to the announcement by avoiding traditionally boring photos of building exteriors. The brochure generated a positive response, and the firm followed up with a series of spin-off mailers.

Design Firm: Addison
Art Director: David Kohler
Designer: Christine Wolter
Photographer: William Vazquez
Copywriters: David Kohler, Christine Suarez
Client: Dolan Wohlers Terwilliger
Printer: Dolan Wohlers Terwilliger

*"we have a new plant that's a dream,
in the midst of the country so green,
this isn't just blarney,
said a man from Killarney,
to be believed it has to be seen!"*

Happy St. Patrick's Day from the whole plant!

Paper Stock: Neenah Classic Crest 80 lb. cover
Printing: 4-color process, plus one match color and spot satin varnish, sheetfed
Print Quantity: 1000 each of 7

When the objective is to expand the business, one or two mailers annually will not be compelling. Experts say that an effective direct-mail program requires regular contact with the prospect. That's exactly the route taken by Addison in this series of holiday cards designed for commercial printer Dolan Wohlers Terwilliger.

The simple holiday cards arrive throughout the year. They provide a gentle, friendly reminder of the printer's services and commitment to quality, all the while playing to its theme that the card comes from the whole plant, which, incidentally, reinforces the brochure that announced the company's new facility.

" First, we've got to attract their attention with something colorful. Ultimately, it needs to be **comforting,** satisfying and reassuring. "

" We don't need to **cover** a lot of territory, just the **essentials** – the stuff that's **really hot.** "

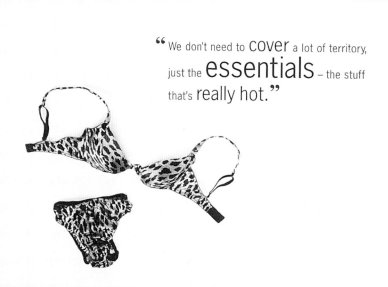

" I want it to be **interactive,** **energetic** and fun. Once we set it in **motion,** it should continue on its own. "

ADDISON CORPORATE LITERATURE
CARD MAILERS

Design Firm: Addison
Art Director/Designer: Brian Cunningham
Photographer: Spencer Jones
Copywriters: Brian Cunningham, Ginger Gonzalez
Client: Addison
Printer: Stevens Press

Paper Stock: Consort Royal Dull 120 lb. cover
Printing: 4 over 4, sheetfed
Print Quantity: 2000 each of 6

The perfect union of copy to graphic is exemplified in this self-promotion. The images of pacifier, skimpy bikini, and grenade are perfectly married to the copy, which speaks to the potential pratfalls in the client/agency relationship. In this six-time, direct-mail campaign, Addison pokes fun at these problems while simultaneously reassuring prospective clients that this won't happen with Addison. The campaign generated immediate response. You know you've hit on a memorable message when recipients decorate their offices with your self-promotion and share the mailers with their staff.

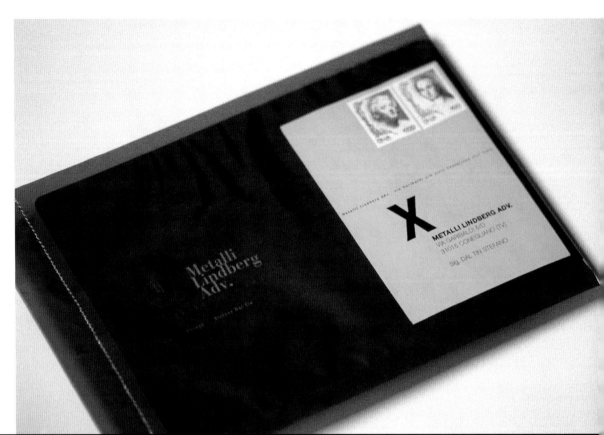

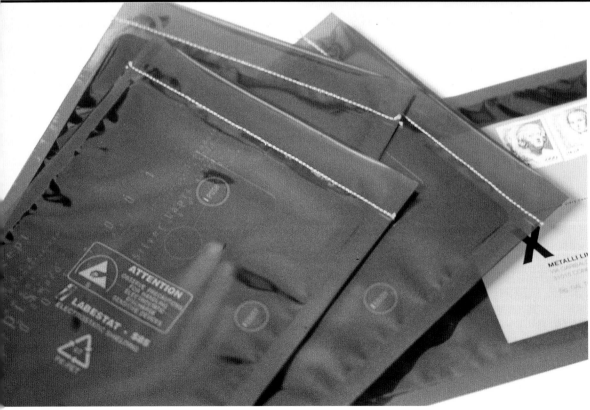

Design Firm: Metalli Lindberg Adv.
Creative Director: Lionello Borean
Account Manager: Stefano Dal Tin
Designers: Susy Vedavato, Owen M. Walters
Client: Metalli Lindberg Adv.
Printer: Se.Graf. SpA

Paper Stock: Card stock 350 g.
Printing: 4-color process plus two spot colors, Braille characters printed in relief and punched, synthetic resin applied by screen-printing, perforated
Print Quantity: 1200

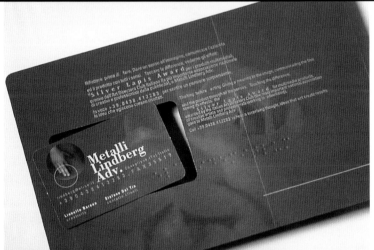

Metalli Lindberg went all out with this self-promotion that was designed to announce its award-winning multimedia work. The mailing envelope duplicates those used by the electronics industry for computer boards, except that Metalli Lindberg seals it with hand-stitched tailor's thread. Inside, a card introduces the concept: "Think before/Act and push." Raised buttons are screen-printed in resin to give the card an immediate tactile appeal. A perforated business card with the agency's telephone number is also included. Each element has its own texture, and together with the unusual materials, they create a memorable mailer. When Metalli Lindberg followed up on the mailing, the firm discovered that 95 percent of those targeted not only remembered receiving it, but also had detached the card for future reference.

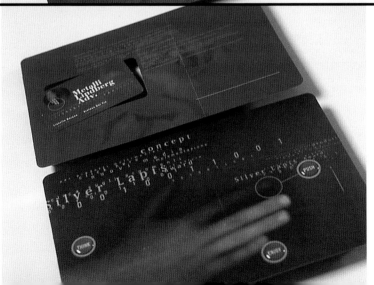

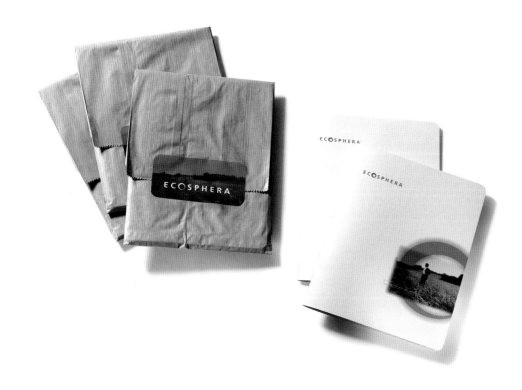

ECOSPHERA BROCHURE

Design Firm: Metalli Lindberg Adv.
Creative Director: Lionello Borean
Account Manager: Stefano Dal Tin
Client: Ecor SpA
Printer: Se.Graf.SpA

Paper Stock: Cordenons Tintoretto 250 g.
Printing: 2 colors (label)
Print Quantity: 2000

Ecosphera represents a new way of distributing organic-food products. To introduce the concept and initiate telephone contact with the company, Ecor SpA sent this direct-mail package to owners of health-food stores. A plain brown kraft bag—traditionally associated with grocery products—served as the envelope. It is sealed with a label featuring the company's logo. Inside, a brochure details Ecosphera products. Immediately after this piece was mailed, a company representative visited the potential customer, who by then was already familiar with the Ecosphera concept.

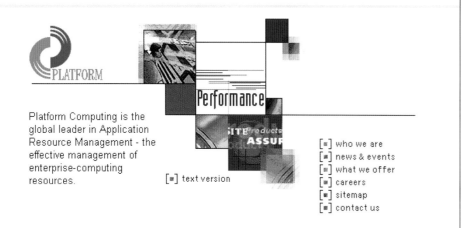

PLATFORM

Platform Computing is the
global leader in Application
Resource Management - the
effective management of
enterprise-computing
resources.

Performance

SITE products
ASSUR

[■] text version

[■] who we are
[■] news & events
[■] what we offer
[■] careers
[■] sitemap
[■] contact us

PLATFORM COMPUTING WEB SITE
www.platform.com

Design Firm: Yfactor, Inc.
Art Director: Anya Colussi
Designer: Jeanine Churchill
Client: Platform Computing

PLATFORM

Careers

[■] who we are [■] news & events
[■] what we offer [■] contact us
[■] sitemap [■] home

[Discover Platform]

Do you want to
shape the future
of computing
throughout the
world by working
for, and being one
of the owners in,
a company that
is experiencing
explosive growth?

Opportunities

-Any Country- ▾
-Any Department- ▾ Go

Search by Keyword
[] Go

PLATFORM

LSF Industry Solutions

[■] who we are [■] news & events
[■] what we offer [■] careers
[■] sitemap [■] contact us
 [■] home

In this section you
will find customer
success stories,
white papers, benefit
overviews, and other
useful information that
clearly demonstrates
why the LSF Suite
has become the
industry standard in
Application Resource
Management

view by: ▾

Search By Keyword:
[] Go

With the advent of the Internet, direct response no longer is lim-
ited to paper designs delivered through the postal service.
Increasingly, Web sites are used to trigger a response. The trick
of effective direct-response Web graphics is to make a site as
effective as a traditional mail piece. Yfactor excels in this area.
Platform Computing's site uses corporate colors, which coinci-
dentally also are friendly colors. The site presents animated
graphics and easily retrieved information and data. The site's
design also motivates visitors to search for jobs and send in a
resume. Prospective customers can browse a database of docu-
ments and case studies on Platform's products.

EURO CONSULTING BROCHURE

Design Firm: Format Designgruppe
Designer: Knut Ettling
Copywriter: Jan Kuhlmann
Client: Pauli & Partner Unternehmensberatung GmbH

Paper Stock: Fly 135 g.
Printing: 1 color, offset
Print Quantity: 5000

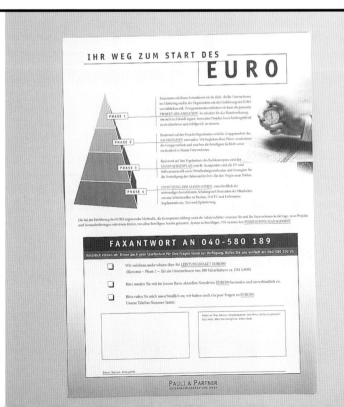

The introduction of the Euro represented the debut of a new European currency and produced many problems, ones that consultants were eager to solve. Format Designgruppe created this simple, trifold brochure to generate business leads for its client, specialists in Euro-problem consulting. The sparse use of color highlights the mailer's key feature, a ten-item checklist for preparation before the advent of the Euro. A ready-made fax cover sheet, requiring minimal effort by the recipient, resulted in a call for help from 6 percent of those targeted.

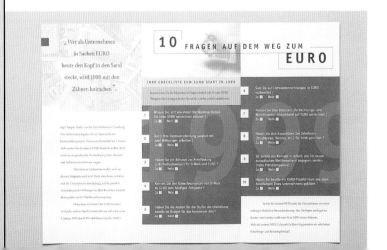

GRECO DESIGN STUDIO SELF-PROMOTION

Design Firm: Greco Design Studio
Art Director/Designer/Illustrator: Andrea Greco
Photographers: Andrea Greco, Alex Bunone
Copywriter: Andrea Greco
Company Mascot: Matisse, Greco's Dalmatian
Client: Greco Design Studio
Printer: Punto & Linea

Paper Stock: Cover—Bristol 250 g., Text—Patina Brilliant 170 g.
Printing: 4-color process, digital
Print Quantity: 500

To achieve maximum impact for minimal expense, this designer opted for digital printing. Thus, he provided a cost-effective, four-color venue to display his design portfolio. The result is akin to a high-end graphic magazine. The layout is clean and efficient. The color, provided by Greco's choice of projects, energizes the pages. Presented in both English and Italian, the copy is kept short to enhance the visuals. Greco showcases about twenty-six works that range from logos and CD-ROM covers to posters and much, much more. Rarely would one get enough time with a prospect in an initial meeting to cover this much ground. Of the 500 brochures printed, Greco has mailed out 100 to date and is pleased with the response.

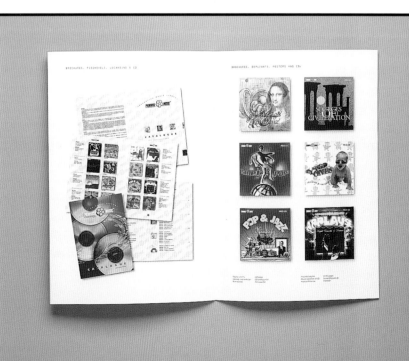

Pop the CD into a computer, and a box of interactive gadgets appears, accompanied by the sound of presses running in the background.

Users also can take a virtual tour of the plant, filmed with Super 8 black-and-white movie technology for the feel of a newsreel, which contrasts with the balance of the cutting-edge multimedia presentation.

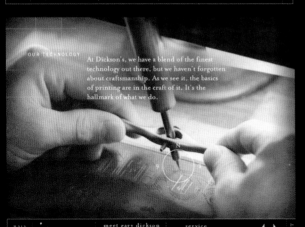

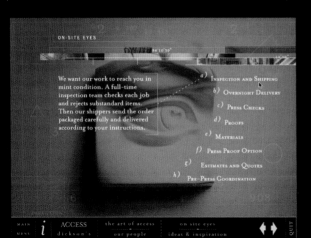

The CD allows designers to access Dickson's Web site directly to request estimates, download information on specialty processes, and send in orders, all of which makes life easier for the prospect. As an added bonus, Dickson's has included a special game on the CD where players literally bounce around an idea before a client shoots it down.

ACCESS DICKSON'S CD-ROM

Design Firm: Melia Design Group
Art Director: Jennifer Cooper
Designer: Mike Melia
Client: Dickson's, Inc.
Printer: Dickson's, Inc.

Paper Stock: Mohawk Superfine 80 lb. cover
Printing: 7 colors, offset, foil-stamped, engraved, die-cut
Print Quantity: 5000

The goal of this Mac-based CD-ROM is to help graphic designers and print buyers around the world access Dickson's, Inc., an Atlanta-based printer, from their own backyard. "Designers are accustomed to dealing with printers in their neighborhood, but with today's technology, our neighborhood is the world," said Gary Dickson, president.

The design of the CD jacket prominently features two cans connected by a string —the world's simplest form of communication between two individuals.

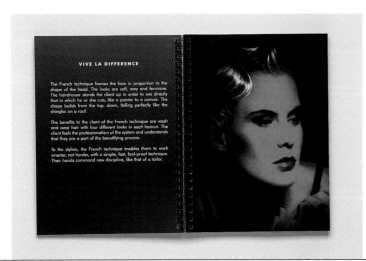

JAMISON SHAW ADVANCED
HAIRDRESSING SYSTEMS BROCHURE

Design Firm: Jamison Shaw Hairdressers In-house
Art Director/Designer/Illustrator: Jil Wyland
Copywriter: Freddy Codner
Client: Jamison Shaw Hairdressers
Printer: Dickson's, Inc.

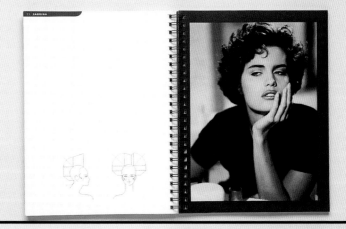

Paper Stock: Utopia Two Gloss blue white 100 lb. cover
Printing: 3 colors, offset, foil-stamped
Print Quantity: 1500

This exquisite book, rich in duotone photography, more closely resembles a photographer's portfolio than a book of hairstyles and cutting techniques from one of Atlanta's première hair salons. The photos of women with stylish cuts are beautifully rendered and face stark white pages with minimalist graphics that detail the cuts. Throughout, the style is direct and to the point, down to the final plea on the last page directing readers to call, write, or visit Jamison Shaw's Web site.

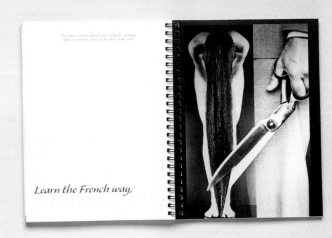

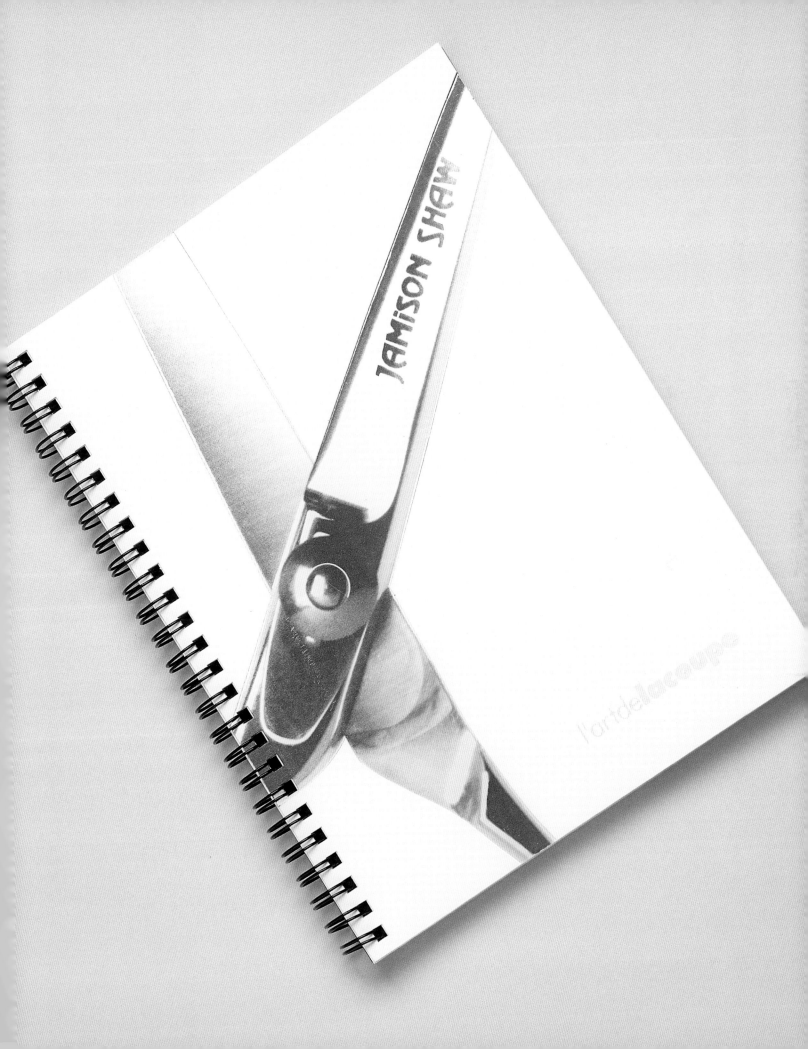

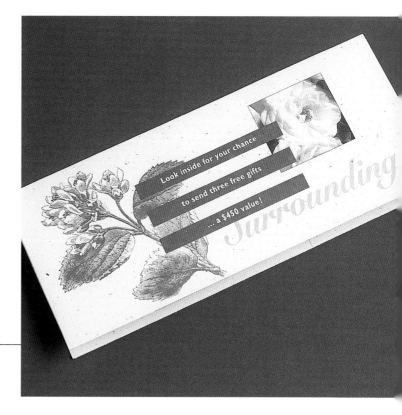

SURROUNDINGS REMINDER MAILER

Design Firm: Lieber Brewster Design, Inc.
Art Director: Anna Lieber
Copywriter: Surroundings
Client: Surroundings
Printer: Howard Press

Paper Stock: Mohawk Satin Cream White Recycled 65 lb. cover
Printing: 2 colors, sheetfed

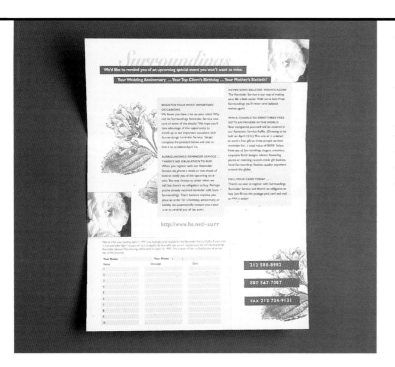

This self-mailer for Surroundings, a reminder service that ensures that you'll never forget another birthday or anniversary again, is awash in gray and soft purple. The subtlety of the piece makes it stand out from the majority of mail that tends to scream, "Toss me!" versus the more desirable, "Read me!" Once hooked, it's easy to respond. No fluff appears here. Copy is minimal, and graphics match the color palette. Best of all, the reply card lets recipients list all the "reminders" that they want and gives them the choice of faxing or mailing their replies—postage paid, of course. As an additional incentive, responses were entered into a raffle with the opportunity to win three free gifts sent anywhere in the world.

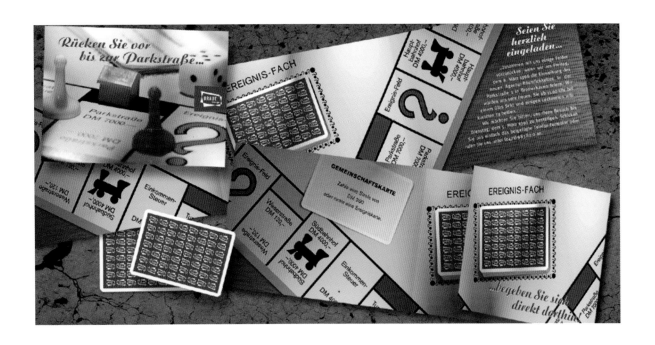

BRAUE DESIGN MONOPOLY INVITATION

Design Firm: Braue Design
Art Director: Kai Braue
Designers: Kai Braue, Raimund Fohs
Illustrator: Raimund Fohs
Photographer: In-house digital photo composing
Copywriters: Kai Braue, Raimund Fohs
Client: Braue Design
Printer: Druckerei Werner

Paper Stock: Profistar 170 g/m²
Printing: 4 colors, offset
Print Quantity: 200

To commemorate their move uptown, Braue Design extended an invitation to visit its new headquarters modeled after the famous Monopoly board game. The idea provides instant name recognition of its new location on Parkstrasse, the German equivalent of the American board game's Park Place. The design's universal appeal created a memorable impression among recipients and won many new contacts.

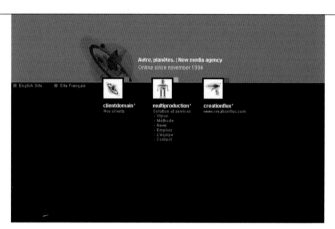

AUTRE, PLANÈTES WEB SITE
www.autre-planetes.fr

Design Firm: Autre, Planètes
Art Directors: Thierry Charbonnel, Patrick Poisson
Designers: Nadège Bertrand, Thierry Charbonnel, Patrick Poisson
Client: Autre, Planètes

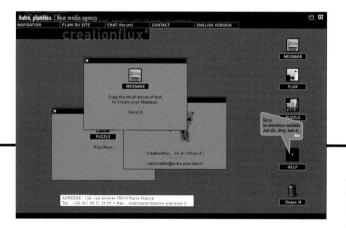

Autre, Planètes, a design firm with considerable experience in on-line design work, has created an interactive site of its own that demonstrates its talents and provides valuable information. The interactivity of the site involves the viewer and grabs attention. It invites visitors to create their own message (from a point that differs substantially from typical E-mail formats) or to play a virtual version of a magnetic poetry puzzle.

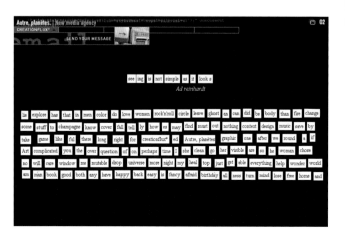

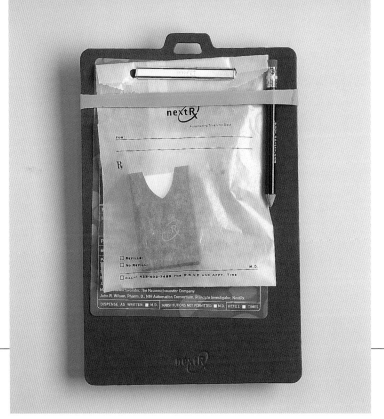

NEXTRX INVITATION/ANNOUNCEMENT

Design Firm: Hornall Anderson Design Works, Inc.
Art Director: John Hornall
Designers: Julie Lock, March Chin Hutchinson, Mary Hermes, David Bates
Copywriter: NextRx Corporation
Client: NextRx Corporation
Printer: MC Lile

Paper Stock: Clipboard—Bainbridge black/gray 50/50 board, Postcard and Smit wrap—Starwhite Vicksburg Tiara, smooth 65 lb. cover, Envelope—Glacene
Printing: Clipboard—blind emboss, Postcard—1 color (special mix blue metallic), offset, Smit wrap (fast) 3 spot colors, direct to plate, Smit wrap (final) 4-color process, offset, Envelope—1 color, screened
Print Quantity: Clipboard—175, Postcard—10,000, Smit wrap—10,000, Envelope 175

Hornall Anderson Design Works, Inc. created this unique item to resemble a doctor's clipboard, complete with a glassine prescription bag containing a token box of "Smits," fashioned to look like drug dispensers. Its goals were twofold: to announce the new product and to invite prospective buyers of automated drug distribution system to schedule an appointment in order to see the machines before deciding whether to purchase.

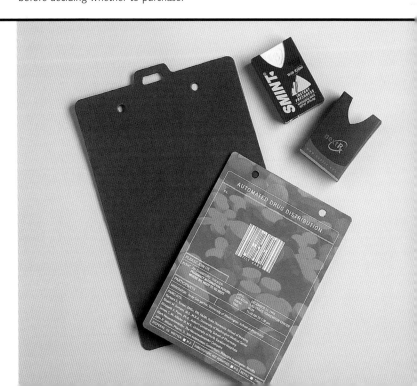

STEWART MONDERER DESIGN, INC.
WEB SITE SELF-PROMOTION

Design Firm: Stewart Monderer Design, Inc.
Art Director: Stewart Monderer
Designers: Stewart Monderer, Jeff Gobin
Copywriter: Jeff Gobin
Client: Stewart Monderer Design, Inc.
Printer: Pride Printers

Paper Stock: Coated 100 lb. cover
Printing: 4-color process, sheetfed
Print Quantity: 5000

When Stewart Monderer Design went on-line, the firm issued two postcards—one showcased five client logos designed by the firm, and the other featured thumbnails of client works beneath the headline, "Find out what these companies already know." The front of each card does an effective job of selling the firm's design capabilities, even without the reverse, which provides plenty of information for anyone still looking for details. According to Stewart Monderer, the response was great and prompted many unsolicited calls from clients and prospects.

REGINA FERNANDES ORIGINAL WATERCOLOUR PAINTINGS POSTCARD

Design Firm: ReDesign
Designer/Illustrator/Copywriter: Regina Fernandes
Client: Regina Fernandes
Printer: ReDesign Studio

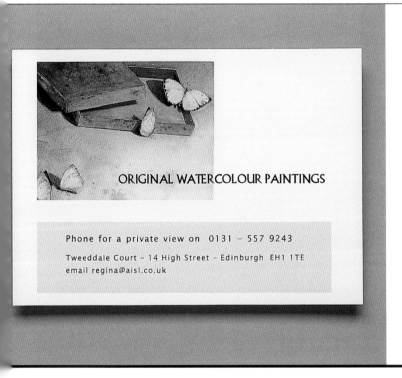

ORIGINAL WATERCOLOUR PAINTINGS

Phone for a private view on 0131 – 557 9243

Tweeddale Court – 14 High Street – Edinburgh EH1 1TE
email regina@aisl.co.uk

Paper Stock: Epson photo-quality inkjet card
Printing: 4 colors, sheetfed

Regina Fernandes' goal was to inspire enough calls for private viewings of her watercolor paintings in order to generate some sales. Because the postcard shows one of her works, the reproduction had to be accurate, which can be hard to do on a budget. Nevertheless, Fernandes succeeded, printing this postcard on—of all things—photo-quality inkjet stock. The card worked. It generated phone calls and to date has resulted in five sales.

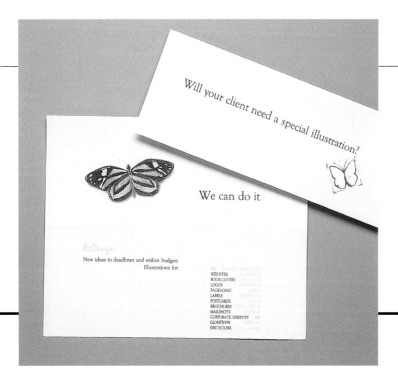

REDESIGN ILLUSTRATION MAILSHOT

Design Firm: ReDesign
Designer/Illustrator: Regina Fernandes
Copywriter: ReDesign
Client: ReDesign
Printer: ReDesign Studio

Paper Stock: Fox River Phase 2 recycled ivory 90 gsm.
Printing: 4 colors, sheetfed

This mailer, though created on a budget, is no less effective. It asks, "Will your client need a special illustration?" Inside, it answers directly: "We can do it." No fluff appears here. Instead, the butterfly illustration and unique type treatments capture the eye. Especially hard to miss is the litany of services that sport a twist on the typical list format. The mailing netted many responses and some new clients.

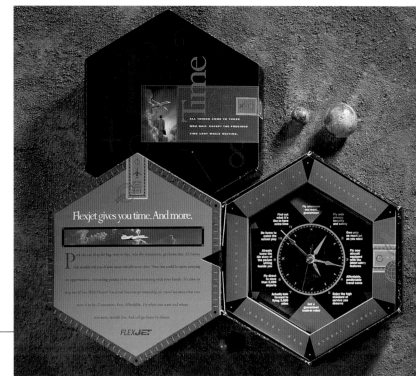

BOMBARDIER AEROSPACE FLEXJET TIME MAILER

Design Firm: Greteman Group
Art Directors/Designers: Sonia Greteman, James Strange
Photographer: Paul Bowen
Copywriter: Raleigh Drennon
Client: Bombardier Aerospace
Printer: Printing Inc.

Paper Stock: Carolina
Printing: 7 colors, offset
Print Quantity: 25,000

This mailing was so powerful that just one month after it was mailed, the client's sales leads doubled. Targeted to upper management and key decision makers, the piece communicates how fractional jet ownership reduces travel time and aggravation. The movable clock hands point to each benefit while subtly reinforcing the message of saving travel time.

Design Firm: Julia Tam Design
Art Director/Designer: Julia Tam
Illustrator: Kirk Caldwell
Copywriter: Dennis Moore
Client: Houlihan Lokey Howard & Zukin
Printer: Lithographix

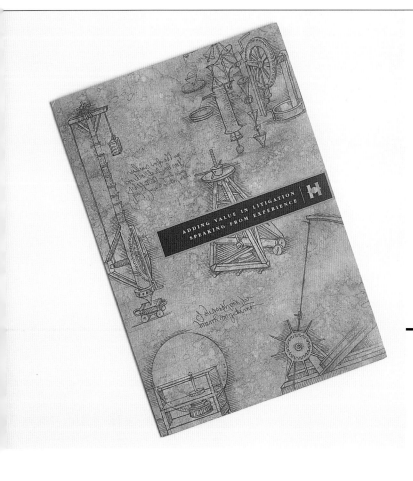

Printing: 6 colors, offset
Print Quantity: 50,000

A refreshing twist on the traditional pocket folder appears in this beautifully illustrated brochure for a group of attorneys. The folder does away with the pocket, adds a third inside panel, lays out a full range of capabilities on the inside spread, and features a series of three, stepped die-cuts that hold the uniformly cut bio and credential sheets of the principals. The information most likely to require regular updating appears on the inserts. Thus, the most costly portion of the brochure benefits from a long life, while the inserts are easily and cost effectively revised as needed.

A UNIQUE ALTERNATIVE FOR EXPERT TESTIMONY

As a diversified financial services and investment banking firm, Houlihan Lokey Howard & Zukin has consistently appeared in annual rankings of the country's top-20 M&A advisors. With more than 300 employees located in nine offices throughout North America, Houlihan Lokey provides a wide range of services to its clients, including business and securities valuations, fairness opinions, solvency opinions, financial restructuring, mergers and acquisitions services, private placements of debt and equity, merchant banking services, and dispute analysis and expert testimony.

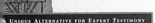

BEYOND THEORY

Houlihan Lokey's dispute analysis professionals go beyond theoretical models to bring real-world experience to contested issues. Because these professionals work on a variety of transactional and financial advisory assignments as well as on litigation matters, they are able to incorporate real-world experience, insights and anecdotes into their testimony that others cannot. For example, as a leading provider of independent fairness opinions in pending transactions, Houlihan Lokey is often retained as an expert witness to address fairness concerns about past transactions. This experience enhances the credibility of Houlihan Lokey's expert witnesses, and makes their testimony more difficult to challenge.

EFFECTIVE COMMUNICATION OF COMPLEX FINANCIAL TOPICS

The ability to communicate complex business issues and financial theories in a clear, precise manner may be the single most critical element of expert testimony. On a daily basis, Houlihan Lokey professionals present the results of their analyses to attorneys, company owners or management, accountants, bankers, shareholders, bondholders and governmental agencies. This experience means that Houlihan Lokey's expert witnesses can effectively communicate their positions and reasoning to a judge and jury.

National Resources:

Houlihan Lokey's size and diverse resources allow the firm to execute large-scale projects efficiently, thoroughly and accurately. With more than 180 financial professionals located in nine offices throughout North America, Houlihan Lokey can assemble the appropriate team for any assignment.

UNPARALLELED FINANCIAL RESEARCH

Houlihan Lokey's research staff is comprised of more than 40 professionals nationwide conducting ongoing industry and market research. Additionally, the firm owns Mergerstat, a leading publication of mergers and acquisitions data for more than 30 years, and publishes the Control Premium Study, a widely distributed source of market data on control premiums paid in transactions. These readily available sources of information, together with our experienced research staff, allow Houlihan Lokey professionals to compile data and information quickly and economically, a critical advantage in short-turnaround and cost-sensitive projects.

EXPERIENCED EXPERT WITNESSES

Houlihan Lokey's dispute analysis professionals are among the firm's most experienced officers. These officers have been designated as expert witnesses in hundreds of lawsuits and have testified in numerous venues throughout the country, including:

- United States District Court
- United States Bankruptcy Court
- Numerous State Courts
- United States Tax Court
- Regulatory Agencies
- American Arbitration Association

HIGHEST LEVEL OF ATTENTION

Houlihan Lokey adheres to the philosophy that a high degree of senior-level involvement is required throughout a litigation assignment in order to assure results that meet the high expectations of our clients. Each assignment is managed by the testifying expert from start to finish. This hands-on approach assures both the timely completion of the project and a more thoroughly prepared witness.

MADISON ADVERTISING MANAGEMENT
COASTER MAILING

Design Firm: Graif Design, Inc.
Art Director/Designer/Illustrator: Matt Graif
Client: Madison Advertising Management
Printer: A.C.S. Printing Co.

Paper Stock: Coaster card stock
Printing: 2 colors, letterpressed and embossed
Print Quantity: Coasters–2500, Cans–500

Madison Advertising Management used a gift consisting of a tin can and set of eight coasters as a special thank you to customers and as an introductory mailing to prospects. Ninety percent of customers acknowledged the gift, and 5 percent of cold-call prospects responded favorably.

LIMPIA REFRESHING TOWELETTES BROCHURES

Design Firm: Studio GT & P
Art Director/Designer: Gianluigi Tobanelli
Photographer: V. Capacci
Client: Diva International S.r.L
Printer: Eurolito S.a.s.

Printing: 4 colors, offset

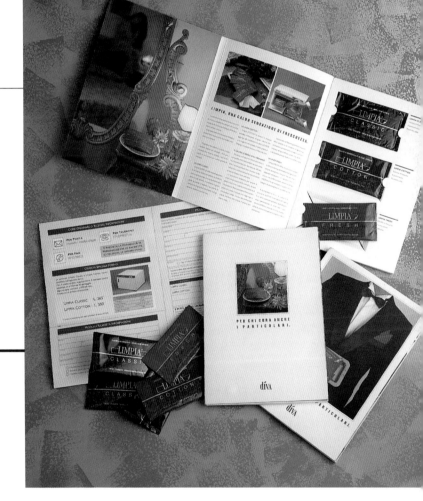

Two brochures were created to promote two different styles of high-end towelettes to upscale hotels and restaurants. Elegantly designed, both brochures effectively included product samples. More important, the brochures included a form that allows prospective customers to purchase directly. All of this made contacting the company stress free, as refreshing as the feeling provided by the warm towelettes that recipients were sampling.

ERWIN ZINGER GRAPHIC DESIGN
SELF-PROMOTION

Design Firm: Erwin Zinger Graphic Design
Art Director/Designer: Erwin Zinger
Copywriter: Eric de Wal
Client: Erwin Zinger Graphic Design
Printer: Plantijn Casparie

Paper Stock: Cover—Grey board 400 g/m², Inside—Popset white 240 g/m²
Printing: Offset
Print Quantity: As needed

Erwin Zinger Graphic Design earned a 30 percent response rate with this self-promotion; 3 percent of those inquiries have been converted into actual jobs to date. It is easy to see why. Erwin Zinger credits much of the mailer's success to the use of fluorescent inks and the graphic of a man's bald head transitioned into a light bulb. Coupled with that, the mailer's construction and personalization make it a keeper, even if the recipient doesn't respond immediately.

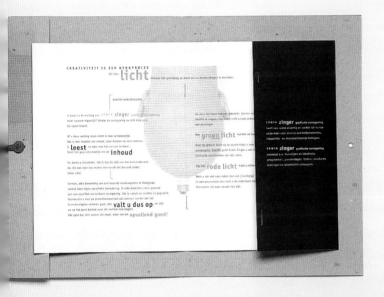

The envelope latches with an unusual plastic closure. When opened, the envelope becomes part of the brochure's binding, adding reinforcement and substance because the two are inseparable. The brochure cover above reveals a more detailed version of the envelope head/light bulb graphic, which is repeated in a tangy orange fluorescent inside.

Folding out the final panel reveals two reply cards—both personalized with the name, address, and telephone number of the prospect. Even better, Zinger includes a peel-off stamp—so that response is easier than ever.

GRAIF DESIGN, INC. SELF-PROMOTION

Design Firm: Graif Design
Art Director: Matt Graif
Designer/Illustrator/Copywriter: Matt Rose
Client: Graif Design, Inc.
Printer: Lorenz Lithographics

Paper Stock: Folder—Mohawk 100 lb. cover, Inserts—70 lb. text
Printing: Folder—3 colors, Inserts—4-color process, offset
Print Quantity: 1000

Graif Design took a lighthearted approach to selling its graphic services, specifically, in its fill-in-the-blank format that personalizes the mailing for each recipient. The piece is clever and memorable due to the folder's customization and seven inserts that get right down to business, providing a variety of examples of Graif's work and range. The mailing generated approximately a 15 percent response rate on cold calls, 5 percent of which won jobs. These are not bad results for a project that was created entirely on trade-outs and favors.

WILLIAMSON PRINTING CORPORATION
LUMINEIGHT™ CD-ROM

Design Firm: Williamson Printing Corporation
(CD-ROM based on brochure designed by Lidji Design Office)
Designer: Mark Novak
Client: Williamson Printing Corporation

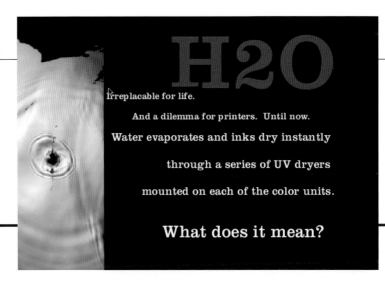

Williamson Printing Corporation approached prospective designers on two fronts when introducing its new LuminEight process. Williamson asked the Lidji Design Office to create a brochure that provided the ideal forum to demonstrate the process (page 122). Then the firm incorporated those visuals into an auto-run CD-ROM presentation that plays on both Mac and PC platforms. That way, designers preferring an electronic interplay would still get the message. The visuals chosen for the CD parallel the brochure, but where some might appear static on-screen, these don't. They are alive with color and demand action. As the last frame says, "Go for it."

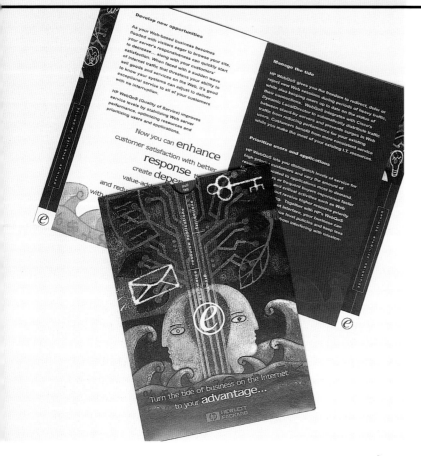

Design Firm: The Riordon Design Group Inc.
Art Director: Ric Riordan
Designers: Dan Wheaton, Sharon Porter
Illustrator: Sharon Porter
Copywriters: Sam Lightman, Edwards Adlers
Client: Hewlett-Packard
Printer: Contact Creative Services Inc.

Paper Stock: Frostbrite Matte 80 lb. cover
Printing: 4 over 5 with matte varnish, offset
Print Quantity: Large brochure—1000 English, 200 French,
Pull-out brochure—4000 English

One would never guess that this two-part promotion for Hewlett-Packard was created with a careful eye on the budget. "The larger piece was created first, and the intent was to amortize the cost of the illustration and graphics over to a subsequent piece geared to a different market," said Ric Riordan. "The two budgets combined enabled us to create more interesting production for the second piece and run four-color process for both." The atypical earth-tone graphics and the interactive pull-out component of the second mailer generated a response that exceeded all expectations.

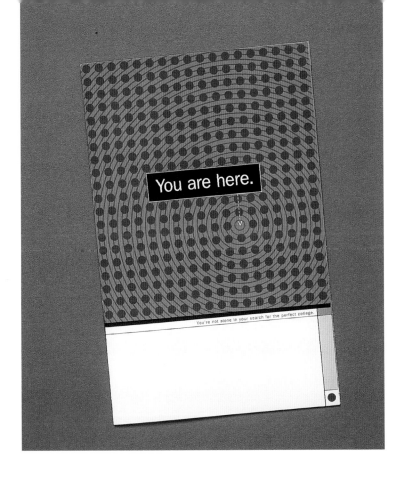

LORAS COLLEGE BROCHURE

Design Firm: Get Smart Design Co.
Art Director: Jeff MacFarlane
Designer: Tom Culbertson
Photographer: Jason Jones
Copywriter: Get Smart Design Co., Jan Powers
Client: Loras College
Printer: Union-Hoermann Press

Paper Stock: Mirage Gloss text and cover
Printing: 4-color process plus spot gloss varnish, sheetfed
Print Quantity: 30,000

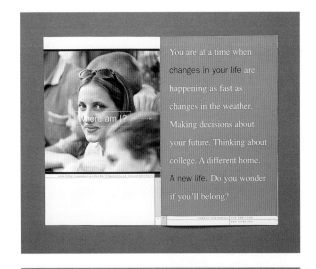

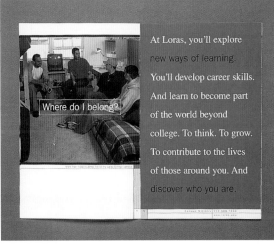

Loras College appealed to teenagers where they live by using lively graphics, and most important, by answering questions like "Where am I?" and "How will I fit in?" that are top-of-mind with high school students. The brochure, which marked a departure from traditional college-recruitment brochures, generated a 15 percent return, considerably higher than the academic direct-mail standard of 8 percent, according to Jeff MacFarlane, art director.

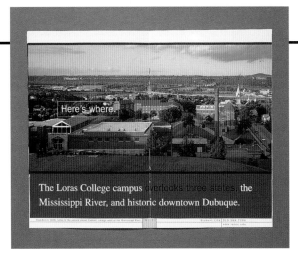

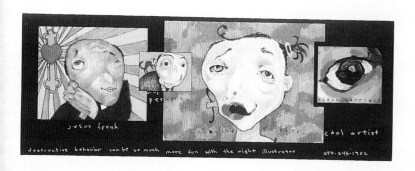

Design Firm: Steven Verriest
Designer/Illustrator: Steven Verriest
Client: Steven Verriest
Printer: White Pine

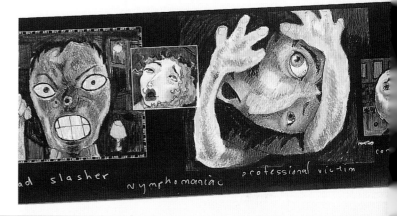

Paper Stock: Starwhite Vicksburg Gloss 100 lb. text
Printing: 4-color process plus varnish
Print Quantity: 2000
Mail Quantity: 700

Steven Verriest, a prolific illustrator, demonstrates not just his skill at illustration, but also his sense of humor and penchant for pop-culture icons. The theme of each mailer varies, as does the size. Some are printed on both sides, while others are not. The only thing that appears consistent throughout is Verriest's distinctive style and the abundance of material from which he can draw for mailings. As a result of his concentrated effort, Verriest caught the eye of agents and now has representation. He has made contact with numerous art buyers, and various publications have showcased his work.

OPPOSITE ABOVE
Printer: Future Reproduction
Paper Stock: Starwhite Vicksburg Gloss 80 lb. cover
Printing: 4-color process plus varnish
Print Quantity: 2000
Mail Quantity: 700

OPPOSITE BELOW LEFT
Printer: Future Reproduction
Paper Stock: Starwhite Vicksburg Gloss 100 lb. text
Printing: 4-color process plus varnish
Print Quantity: 2000
Mail Quantity: 700

OPPOSITE BELOW RIGHT
Printer: White Pine
Paper Stock: Starwhite Vicksburg Gloss 100 lb. text
Printing: 4-color process plus varnish
Print Quantity: 2000
Mail Quantity: 700

Increasing Awareness

"Frequency is key. Objections are not rejections. Eighty percent of the time you'll hear, 'I have no need at this time' or 'I'm happy with my current arrangement.' Frequency is being there are on a regular basis so that eventually when prospects develop a need or their number-one supplier leaves, they will think of you."
—Morgan Shorey, The List®

Capturing a consumer's attention in today's marketplace takes more than just hanging out a shingle and making a lot of noise. Designers are acutely aware that increasing their own visibility or that of a client has everything to do with creating a lasting impression. Designers seek an impression that will be remembered long enough to prompt a call months or years after they initially contact a prospect.

Increasingly, awareness marketing and self-promotions verge on entertainment. From a historical perspective, this marks a remarkable evolution in design from the standard capabilities brochures of old. Today, unique, kitschy, and interactive pieces are those ready-made for a built-in time delay. Recipients receive the piece or visit the Web site—remember it, bookmark it, file it, or best yet, keep it on their desktop—but they don't throw it away. All of this ensures that when they are ready to take action, they will contact the top-of-mind company.

Effective awareness-building designs give something back. The best Internet sites don't simply provide information about the company; they offer something of value in return, which, if skillfully planned and designed, encourages frequent repeat visits—the electronic equivalent of regular mailings.

The best awareness-building pieces in this chapter employ these techniques to optimum effect. They are diverse, ranging from a financial Web site to gadgety object mailings. But all have in common the fact that they effected the prospect as intended. In each case, the prospect learned something about the sender and then remembered the name on the shingle.

APRILIA LEONARDO 250 PRESS KIT

Design Firm: Metalli Lindberg Adv.
Creative Director: Lionello Borean
Designer: Derek Stewart
Account Manager: Stefano Dal Tin
Photographer: Albert Narduzzi
Producer: Roberta Lorenzet
Client: Aprilia SpA
Printer: Graficart SpA

Paper Stock: Fedrigoni GSK translucent paper 170 g.
Printing: 4-color process plus 1 PMS color
Print Quantity: 1000

It is no easy feat to motivate the media to cover your products, even if the product has a certain amount of sex appeal—Italian motorcycles. Aprilia wanted to spread the word about its new products, particularly about its high-tech scooter, the Leonardo 250. To seize media attention, a dramatic press kit was designed with bubble-wrap as a primary component. The translucency of the packing material reveals the Leonardo 250 inside and piques interest.

The untraditional materials attracted editorial interest and became a status object among journalists, according to Lionello Borean, creative director on the project. The targeted media gave the new products widespread coverage, netting tremendous exposure in the media at minimal cost.

APRILIA GREEN GENERATION PRESS KIT

Design Firm: Metalli Lindberg Adv.
Creative Director: Lionello Borean
Account Manager: Stefano Dal Tin
Client: Aprilia SpA
Printer: Graficart SpA

Paper Stock: Standard cardboard folder, 500 g., layer of synthetic grass
Printing: Folder—2 spot colors, screen printed, Label—1 color,
Technical charts—4 colors
Print Quantity: 350

Usually logo treatments are sacred. Under no circumstances should one deviate from the corporate standard. Today, however, more companies recognize the need to be flexible—particularly when it comes to their marketing materials. Aprila, an Italian motorcycle manufacturer and winner of twelve world championships, is among those companies leading this trend.

To introduce Aprilia Green Generation, a new range of catalytic scooters, the company took the green theme to the max with its press kit. For starters, the logo went green, a dramatic change from its traditional red. A mat of synthetic green grass was adhered by hand to a standard cardboard folder. In addition to the usual press information, tucked inside the folder was a translucent envelope containing actual seeds to reinforce the company's ecological message. The entire package was slipped into a gardening bag and sealed with a label to complete the presentation. Not surprisingly, editors, flooded with press materials every day, reached for this one, as evidenced by the enormous amount of press coverage received.

Fun Stuff

play some games
make cool things
print & colour
contest corner
mini sites

Check out this Fun Stuff area
for lots of entertainment.
We add new things to do all
the time, so come back often!

kids gallery
Submit your artwork to us and see it
published online!

What's On | Young Kids | Kids | Families | Adults | Who We Are | Fun Stuff | Contests |
Contact Us | Newsletter | Get Us | Home

THE FAMILY CHANNEL WEB SITE
www.familychannel.ca

Design Firm: Yfactor, Inc.
Art Director: Anya Colussi
Client: The Family Channel

Please make sure you have the latest Shockwave/Flash plugin.
If you don't have it, you can get it by clicking here.

young kids

- Letter Game
- Get Counting
- On-line Colouring Book

kids

- Word Search
- Picture Patch

puzzles

- Nilus the Sandman
- The Busy World of Richard Scarry 1
- The Busy World of Richard Scarry 2 ♥NEW!♥
- Mrs. Cherrywinkle
- Billy the Cat
- Kleo the Misfit Unicorn
- Little Lulu 1
- Little Lulu 2 ♥NEW!♥

family

- Franklin Trivia ♥NEW!♥
- Hollywood Trivia Quiz

 kids gallery print & colour make cool things

Yfactor designed this site to encourage visitors to return frequently and to drive viewers to the television network. To ensure frequent visits, the site is regularly updated with themes and colors that reflect the seasons and the current programming. The interactive design, appealing to adults and kids, invites them to play games and respond to the network. So current is the site that visitors can click on a graphic button to see what is showing on the network at any given moment. That delivers not only direct but also timely response.

What's On

Highlights

Monthly grid

News Letter

Get our free monthly Newsletter!

Check out our highlights for
Adults, Families, Kids, and
Young Kids.

See our schedule at a glance
or download our July Guide in
Adobe Acrobat 3.0 format
(pdf). If you don't have the
plug-in, get it here.

daily listings

What's on today or in July. All
times are in Eastern and
Mountain.

What's On
Right Now

Find out
what's on right
now!

Search For: _____

○ Search title ○ Search all

Genre: - Select One - ▼ GO

Programs from A - Z

A B C D E F G H I J K L M N
O P Q R S T U V W X Y Z

NEW YORK CITY PARTNERSHIP DIRECT MAIL

Design Firm: Designation Inc.
Designer/Illustrator: Mike Quon
Copywriter: Willa Apel
Client: New York City Partnership
Printer: Skilltech Global Printers

Paper Stock: Ultrawhite smooth 65 lb. cover
Printing: 4-color process, offset
Print Quantity: 6000

The tangled web of New York City bureaucracy is unsnarled in this piece. It directs recipients to a Web site that provides information about municipal regulations, loan programs, taxing authorities, and more. The fun and colorful cartoon graphics communicate both ease and simplicity—why wait in long lines when answers are a mouse click away? Apparently, the message got through. Designer Mike Quon reports a very good response to the Web-site introduction.

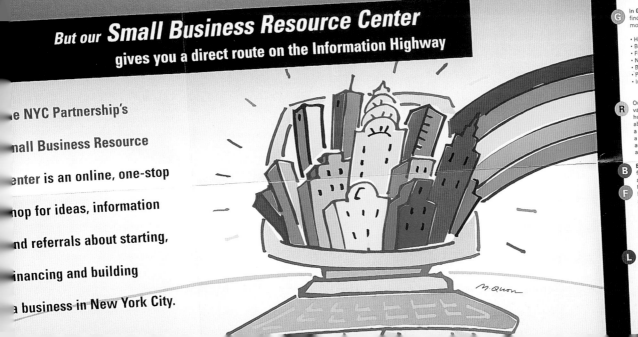

In GETTING STARTED/GROWING BIGGER, you'll find practical information about the issues most new and small businesses face:

- How to Structure a Business in New York
- Business Plan Basics
- Financing a New or Small Business
- Negotiating the Regulatory Maze
- Becoming a New York City Employer
- Planning for Taxes
- Insuring a Small Business

Our RESOURCE LOCATOR will help you pinpoint valuable programs and services without reviewing hundreds of listings. Enter some basic information about your business and the computer will search a database of more than 300 programs to give you a customized list. Click on the name of a program and you'll find a description and a link to the appropriate website.

BRAINSTORMING and FEEDBACK offer opportunities for you to talk to us and to each other. Tell us about the hardest part of starting a business in New York or suggest ways for cutting through bureaucratic red tape. We'll post your comments and encourage others to respond. In the future, look for live chats with experts on various business-related topics. And, of course, we're always interested in your thoughts about how to make the site better.

LINKING UP is a monthly report on our favorite web-sites. There are hundreds of sites devoted to small business, and we're constantly surfing the net to find the best ones.

We watch the headlines, and our FRONT PAGE FEATURE will reflect current issues of concern to the small business community. Future features will include articles on the Year 2000 challenge and energy deregulation.

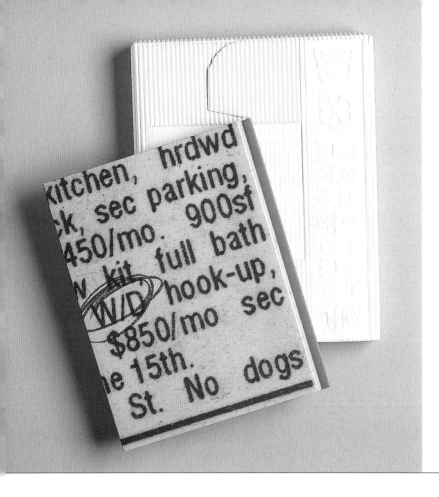

DICKSON'S, INC. & WILLIAMSON PRINTING CORPORATION ALLIANCE ANNOUNCEMENT

Design Firm: EAI
Creative Directors: Phil Hamlett, David Cannon
Designer: Lea Nichols
Photographer: Greg Slater
Copywriters: Robert Roth, David Cannon, Craig Patterson
Clients: Dickson's, Inc., Williamson Printing Corporation
Printers: Dickson's, Inc., Williamson Printing Corporation

Paper Stock: Mohawk Superfine cover and text
Printing: 8 over 8, offset, engraved, foil-stamped, die-cut
Print Quantity: 5000

Announcements of corporate alliances are typically dry, in short, pure drudgery to read. Something else happens with the brochure that announces the alliance of Dickson's, Inc., an artisan in high-end specialty printing, and Williamson Printing Corporation, a master of high-quality Web and sheet-fed printing. This piece encourages not just reading, but also responses. The announcement calls to mind another famous partnership that works best in tandem—the washer and dryer. The washer-and-dryer metaphor is likened to the capabilities provided by Williamson and Dickson's—the washer is a dependable workhorse but cannot deliver perfection without the finishing touch of the dryer.

Just as the copy threads the metaphor throughout the brochure, so do the graphics. Given this pair's expertise, printing and finishing are equally unique. Pages are engraved, foil stamped, and die-cut, the latter done to perfection in order to resemble the pinpoint holes lining the interior of a washing machine.

Designer response to the piece was overwhelming. "Everyone has appreciated the humor of the piece rather than the heavy-handed approach," said Gary Dickson, president, Dickson's, Inc.

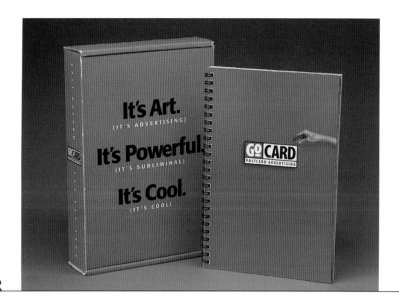

GOCARD BROCHURE MAILER

Design Firm: Mires Design, Inc.
Designers: Eric Freedman, Gale Spitzley
Illustrator: Miguel Perez
Photographer: Mike Campos
Copywriters: John Kuraoka, Alan Wolan
Client: GoCard

Paper Stock: Carolina C2S 10 pt.
Printing: Brochure—4 colors plus 1 PMS color, offset, Box—2 colors
Print Quantity: 2000

GoCards, a collection of free postcards featuring funky, fun, and sometimes risqué advertising slogans, uses a brochure as aggressive in its design as its bold palette of highly saturated colors. The idea that advertising can be so much fun that people would want free copies of an ad in postcard form reflects pop culture's acceptance of marketing in all forms. This brochure generated a lot of buzz in the industry and inspired imitation among GoCard's competitors, according to Mires Design. It's easy to see why. The brochure comes boxed and makes a bold statement upon arrival. Leafing through the brochure is like browsing a catalog of collectibles.

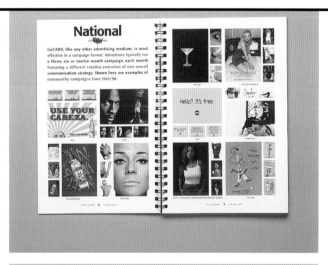

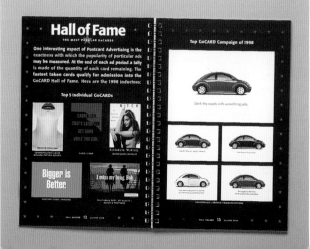

FORMPROGRAMM SELF-PROMOTION

Design Firm: Format Designgruppe
Designer/Illustrator: Knut Ettling
Client: Format Designgruppe

Paper Stock: Noutop 400 g., matte cover
Printing: Cover—3 colors, offset,
Booklet—laser and inkjet printed
Print Quantity: 300

Format Designgruppe promotes its capabilities in a clean, efficient layout that blends several printing technologies. The mainstay elements are offset printed, while most of the contents, which showcase the team's newest and brightest projects, are laser and inkjet printed. This choice ensures that the portfolio, targeted to prospective clients, always is up-to-date and cost-effective, too, particularly for such a small quantity.

ETTLING DESIGN INTERACTIVE
CD-ROM PORTFOLIO

Design Firm: Format Designgruppe
Designer: Knut Ettling
Client: Ettling Design

CD-ROMs are undeniably popular as the new direct-response piece. Unlike Web sites, they operate free of modems, and their speed does not depend on the volume of Internet traffic. Moreover, like Web sites, they often allow users who like what they see the option of E-mailing the company for more information. Such is the case with this interactive design portfolio whose fun approach to Knut Ettling's design work includes an "everything-old-is-new-again" color palette reminiscent of the 1950s.

HADW ON-LINE SELF-PROMOTION

Design Firm: Hornall Anderson Design Works, Inc.
Art Director: Jack Anderson
Designers: Jack Anderson, Chris Sallquist, John Anicker,
Mary Hesler, Shawn Sutherland
Copywriter: Hornall Anderson Design Works, Inc.
Client: Hornall Anderson Design Works, Inc.

Print Quantity: 200

To increase traffic at its new Web site and to promote the firm's new on-line design department, Hornall Anderson Design Works opted for an object mailing that features a message in a bottle. The message was simple, concise, and memorable, proving that some of the most effective communication is short and sweet. Recipients cannot mistake its meaning: www.hadw.com/find-it

HENNINGSEN COMPANY "DESIGNING SUCCESS, BUILDING SOLUTIONS" MAILERS

Design Firm: Sayles Graphic Design
Art Director/Designer/Illustrator: John Sayles
Copywriter: Wendy Lyons
Client: Henningsen Company

Paper Stock: Lustro dull cream
Printing: 3 PMS colors, offset printed, laminated to corrugated
Print Quantity: 7500 each of 3

The Henningsen Company credits more than twenty new projects to this three-part mailing campaign designed to promote its construction services. Each of the three mailers was created with a wood patterned box, illustrated with hinges and screws. Inside, a tray printed with an actual blueprint includes a brochure and one of three specialty items—a tape measure, pocket knife, or level—corresponding to the mailer's headline. The mailers, targeted to potential customers, were sent out in small batches to allow a principal of the firm to follow up personally.

PUNT MOBLES TELEPHONE CARD

Design Firm: Pepe Gimeno—Proyecto Gráfico
Designer: Pepe Gimeno
Client: Punt Mobles
Printer: Sancho Artes Gráficas

Paper Stock: Keaycolour Platino 300 g.
Printing: 2 colors, offset
Print Quantity: 5000

Changing telephone and fax numbers is never hassle-free, but this index-card sized mailer, mailed in an envelope, quickly and effectively spread the word. Its die-cut of a telephone is eye-catching. Its small size makes it a handy reference card, easily kept near the phone. "The response was extremely positive," said designer Pepe Gimeno. "Everyone got used to the new numbers quickly."

THE DYNAMIC OF THE WATER BROCHURE

Design Firm: R2 Design
Art Directors/Designers: Lizá Defossez Ramalho, Artur Rebelo
Client: Teatro Bruto
Printer: Litogaia

Paper Stock: Bindakote Metallizato Argento 250 g.
Printing: 2 over 2, offset
Print Quantity: 500

Despite a low budget, this brochure, designed in frosty Arctic colors, successfully educated its small target audience about the company's doings and convinced many to take Teatro Bruto more seriously. Designers used a metallic paper for the cover to simulate the reflection of water. Supporting visual elements reinforced the idea that, like water, Teatro Bruto is a dynamic, ever-changing company.

WILLIAMSON PRINTING CORPORATION
LUMIN8TIONS BROCHURE

Design Firm: Lidji Design Office
Art Director/Designer: Alan Lidji
Client: Williamson Printing Corporation
Printer: Williamson Printing Corporation

Paper Stock/Printing:
Form 1 Curtis Tweedweave Felt 130 lb. cover, 8 over 7
Form 2 Glamma Natural Translucent 40 lb., 1 over 0
Form 3 King James C1S 8 pt., 9 plus 9 over 0
Form 4 Graphika Vellum, Box Brown 80 lb. cover, 3 over 8
Form 5 Brightwater Incendium Ultra 100 lb. cover, 5 over 6
Form 6 Brightwater Artesian White 100 lb. cover, 6 over 7
Form 7 King James Oyster Pearl 12 pt. cover, 4 over 6
Form 8 Retrieve Hunter Green Felt 80 lb. cover, 4 over 2
Form 9 King James C1S 8 pt., 9 over 0
Form 10 Brightwater Natural Smooth 80 lb. cover, 7 over 6
Print Quantity: 10,000

Williamson Printing Corporation promoted its new eight-color Heidelberg Speedmaster CD, using the LuminEight™ process in this brochure, which obviously required careful planning and orchestration. Each page displays abundant vibrant color. Despite the seeming complexity of the job, it appears more challenging than it was. The copy tells us that, in one pass, the new LuminEight process from Williamson simplifies printing techniques that are considered too complicated or expensive to be printed conventionally. This kind of demonstration and simple, straightforward copy sells.

It's the X*cellent* Ray

UV.

This is the cure.

It's good for what you've got.
Hexachrome?
CMYK Plus Plus on anything?
Metallics?

You'll see more than before.

UV opens up options *&* **closes** down *obstacles*

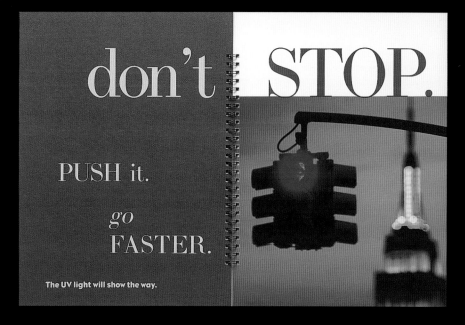

don't STOP.

PUSH it.

go **FASTER.**

The UV light will show the way.

CRÉDIT LYONNAISE WEB SITE
www.creditlyonnais.com

Design Firm: Autre, Planètes
Art Director: Thierry Charbonnel
Designers: Thierry Charbonnel, Patrick Poisson
Copywriter: Crédit Lyonnais
Client: Crédit Lyonnais

The colors on Crédit Lyonnais' Web site get your attention: the choice of the type-style makes it easy to read, its clean layout makes the site easy to navigate, and its graphic style departs from expectations. Traditional financial Web sites often are colored in staid corporate hues that can appear lackluster on screen. This design dramatically simplifies the process of logging into your account to check its status. For anyone who needs additional assistance, a help page flags questionable areas and provides detailed explanations.

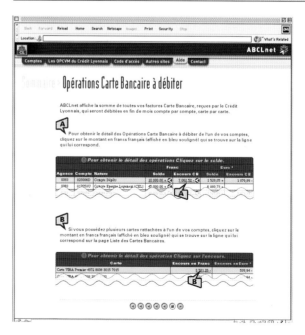

GREENACRES GRAND OPENING ANNOUNCEMENT

Design Firm: Greteman Group
Art Director: Sonia Greteman
Designer: James Strange
Copywriter: Bart Wilcox
Client: GreenAcres
Printer: PrintMaster

Paper Stock: Coin envelopes
Printing: 2 colors, offset
Print Quantity: 2000

Thirty-three percent of recipients responded to this mailer that announces the grand opening of a natural-food store. The mailer was uniquely constructed with coin envelope stock, which gave it an earthy feel. Pea seeds were inserted by hand as a finishing touch.

PATRIMOINE PHOTOGRAPHIQUE WEB SITE

www.patrimoine-photo.org

Design Firm: Autre, Planètes
Art Directors: Thierry Charbonnel, Patrick Poisson
Designers: Nadège Bertrand, Thierry Charbonnel, Patrick Poisson
Copywriter: Ministère de la Culture
Client: Patrimoine Photographique (Ministère de la Culture, France)

Autre, Planètes designed this Web site for Patrimoine Photographique (Ministère de la Culture) to make optimum use of its resources, primarily photographic works that are expertly displayed in an interactive environment. View an artist and click on the button that lets you see examples of his or her work. Depending upon your level of interest or time available, you can dwell on a single work or view a page that sports a gallery of thumbnails, then narrow your focus from there.

Patrimoine photographique

Navigation Présentation Actualités Recherche guidée Espace professionnel English version

DENISE COLOMB

Denise Colomb, de son vrai nom Denise Loeb, naît à Paris en 1902. Après des études de violoncelle au Conservatoire de Paris, elle réalise ses premiers portraits lors d'un séjour en Indochine (1935-1937) où elle accompagne son mari, Gilbert Cahen. Pendant la guerre, elle adopte le pseudonyme qu'elle conservera en tant que photographe. En 1948, Denise Colomb se rend aux Antilles à l'invitation d'Aimé Césaire avant d'entreprendre de nombreux voyages en Inde, en Israël et en Europe. Elle collabore à diverses revues (*Le Leicaiste*, *Regards*, *Le Photographe*, *Réalités*) et effectue des travaux de commande pour *Point de vue-Images du Monde*. Son penchant naturel lui fait représenter l'homme dans ce qu'il a de plus noble, de plus chaleureux. Forte de son éthique, Denise Colomb appartient à la tradition française du réalisme poétique aux côtés de Boubat, Izis, Doisneau et Ronis. C'est avec Antonin Artaud qu'elle

© Ministère de la Culture et de la communication - France

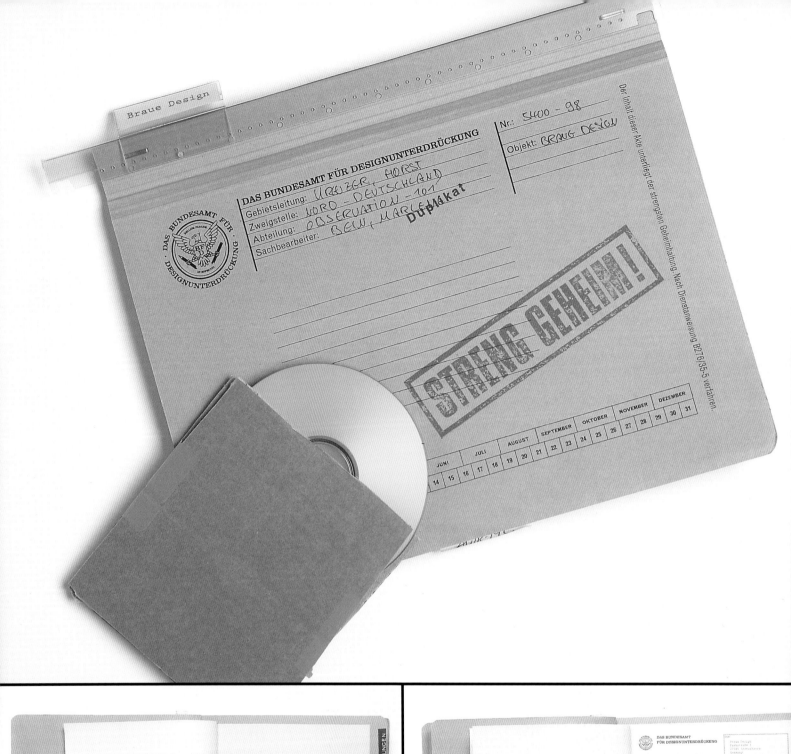

Braue Design

DAS BUNDESAMT FÜR DESIGNUNTERDRÜCKUNG

Nr.: 5400 - 98
Objekt: BRAUG DESIGN

Gebietsleitung: KREUZGR, HORST
Zweigstelle: NORD - DEUTSCHLAND
Abteilung: OBSERUATION - 101
Sachbearbeiter: BEIN, MARLENE

Duplikat

STRENG GEHEIM!

Der Inhalt dieser Akte unterliegt der strengsten Geheimhaltung. Nach Dienstanweisung B276/35-5 verfahren.

JUNI		JULI			AUGUST			SEPTEMBER			OKTOBER			NOVEMBER			DEZEMBER		
14	15	16	17	18	19	20	21	22	23	24	25	26	27	28	29	30	31		

DAS BUNDESAMT
FÜR DESIGNUNTERDRÜCKUNG

NORD - DEUTSCHLAND

Duplikat

Fahrtnachweis Nr. 98/102

PKW OPEL ASTRA WTGH - 1037

HH-BN 203

ANWEISUNGEN
OBJEKTBESCH.
PROTOKOLLE
BEWEISE

DAS BUNDESAMT
FÜR DESIGNUNTERDRÜCKUNG

Braue Design

Beweis 5400 - 98

M. BEIN 15 APRIL '98
NACHT - OBSERVIERUNG

BRAUE DESIGN'S FEDERAL BUREAU OF DESIGN OPPRESSION MAILING

Design Firm: Braue Design
Art Director: Kai Braue
Designers: Kai Braue, Marçel Robbers, Raimund Fohs
Illustrator: Marçel Robbers
Copywriters: Kai Braue, Marçel Robbers, Raimund Fohs
Project Coordinator: Jens Pfennig
Client: Braue Design
Printer: In-house laser prints

Paper Stock: 80 g/m²
Printing: 1 color, silk-screened, laser prints
Print Quantity: 100

Part *Mission: Impossible* and part James Bond thriller, this two-step, self-promotional mailing from Braue Design presents a dossier of the firm's capabilities that is pure entertainment. First, Braue developed the concept of an evil organization that is bent on suppressing good graphic design and a renegade agent who wants to end the organization's reign of terror. Then, concept became reality with part one of the mailing, an audio CD-ROM that explains the plot and hints at the mailing to come.

In phase two, a dossier on Braue Design was mailed—ostensibly prepared by the evil organization, accusing Braue of producing "very good graphic design." The dossier includes plenty of mock evidence from blurry Polaroids down to colored pencil shavings, all carefully collected in plastic bags and labeled.

If this clever approach doesn't sufficiently document Braue's design creativity, then recipients find additional proof in the back pocket, the firm's self-promotional brochure filled with the design firm's real-life portfolio. No blurry Polaroids here—just excellent examples of Braue's work.

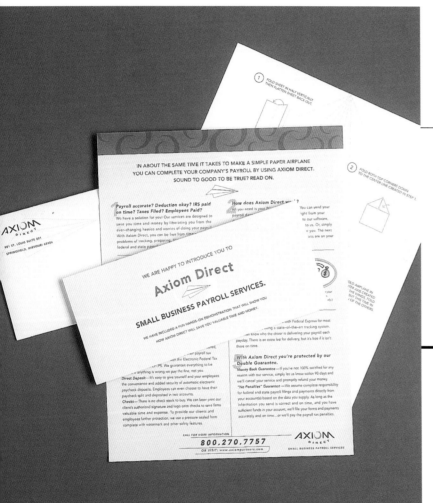

AXIOM DIRECT MAILER

Design Firm: Graif Design
Art Director/Designer/Copywriter: Matt Graif
Illustrators: Matt Graif, Matt Rose
Client: Axiom Direct
Printer: Peerless Group

Paper Stock: Carnival 70 lb. cover and 70 lb. text
Printing: 2 colors, offset
Print Quantity: 5000

Axiom Direct, a small-business payroll service, didn't have the budget for a glamorous new business campaign, so to target a local market Graif Design prepared this simple, three-part mailer. A slim card with minimal copy introduces the company. Features and benefits of the service are boiled down into one page of copy. The third item, a sheet with instructions and fold lines for making your own paper airplane, plays up Axiom's logo. The project successfully increased awareness among prospects, despite its low budget, and the client loved it.

CLARICI BRICK-KILN HANDMADE BRICK MAILING

Design Firm: Studio GT & P
Art Director/Designer: Gianlluigi Tobanelli
Photographer: V. Capacci
Client: Fornaci Laterizi Clarici
Printer: Eurolito S.a.s.

Printing: 4 colors and dull U.V. varnish, offset

For more than a century, the skilled craftsmen at the Clarici Brick-Kiln have made bricks by hand. These bricks are used primarily for restoring or renovating treasured palaces and churches. Studio GT & P designed this mailing to widen the company's market and to encourage more sales among architects and town planners in major Italian cities. It consists of two brochures with a miniature handmade brick as the key selling point. Recipients can judge the quality of the product themselves. One also can bet that recipients kept the brick on their desks as paperweights—a constant reminder of the product.

Williamson

WILLIAMSON PRINTING CORPORATION
ELEVEN-COLOR PRESS BROCHURE

Design Firm: RBMM
Designer: Kenny Garrison
Client: Williamson Printing Corporation
Printer: Williamson Printing Corporation

Paper Stock: Reflections Gloss 100 lb. cover
Printing: 5 over 6, sheetfed 11-color perfector
Print Quantity: 6000

The concept couldn't be simpler: count to eleven with the familiar sing-song of the children's rhyme (one, two, buckle my shoe …) as a means to introduce an eleven-color printing press that prints both sides of the sheet at once. In this instance, the words have been changed to "one, two, a new press for you," as the rewritten lyrics enumerate reasons why designers want to use this press for their next job. Though simplistic, it clearly communicates its message, and that could be one reason why the announcement worked so well.

BERMAN PRINTING CO. HOLIDAY CARD

Design Firm: Wood/Brod Design
Art Director/Designer/Illustrator: Stan Brod
Copywriter: Stan Brod
Client: Berman Printing Co.
Printer: Berman Printing Co.

Paper Stock: Neenah Classic Crest 130 lb. cover, Avon Brilliant White
Printing: 2 colors, offset, and die-cut
Print Quantity: 2500

This interesting greeting card conveys a holiday message and does double duty as a holiday decoration; it also touts the printer's capabilities. No big headlines or catchy copy appears, but the message is unmistakable: Berman Printing Co. is expert at die-cutting.

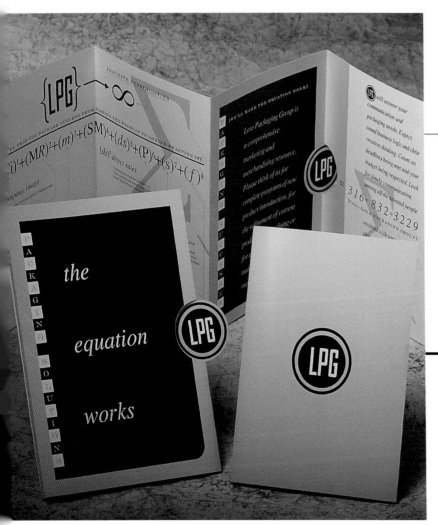

LOVE PACKAGING GROUP
SELF-PROMOTION MAILER

Design Firm: Love Packaging Group
Art Director/Designer/Illustrator: Chris West
Photographer: Jack Jacobs
Copywriter: John Brown
Client: Love Packaging Group
Printer: Don Levt

Paper Stock: 80 lb. slick stock
Printing: 2 colors, offset
Print Quantity: 4000

Bold, black-and-yellow graphics call attention to this self-promotion from the Love Packaging Group. The prominence of the LPG logo also lends distinction and makes it memorable. The four-panel brochure provides the reader with plenty of information and avoids dumping too much data on the recipient.

WILMAC PROPERTY CO. POSTCARD MAILING

Design Firm: Get Smart Design Co.
Art Director: Jeff McFarlane
Designers: Tom Culbertson, Nina Heitzman
Photographer: Jane Melgaard, See Jane Shoot
Copywriters: Jeff McFarlane, Tim McNamara
Client: Wilmac Property Co.
Printer: Union-Hoermann Press

Paper Stock: Fox River Circa Select 80 lb. cover
Printing: 2 over 2, sheetfed
Print Quantity: 2000

Promoting a place called The Warehouse presents a unique challenge because one immediately thinks of vast, empty rooms. However, this warehouse differs from others. This distribution and storage facility doubles as an office building and studio. These features were showcased in a four-installment postcard mailing campaign that hinged on different oversized photos as the primary graphic on each. The campaign netted multiple showings and resulted in two new tenants.

ORANGE SELF-PROMOTION

Design Firm: Orange
Art Director/Designer: Susan Lee
Photographer: Verve Photographics
Copywriters: Jacquine Verkley, Sut Fitterman
Client: Orange
Printer: Metropolitan Fine Printers

Paper Stock: Potlatch McCoy
Printing: 4-color process and silver plus dry trap dull varnish, offset
Print Quantity: 3000

Juicy, succulent orange slices adorn the cover of this brochure that promotes the design services of a firm that bears the same name. Orange creates immediate recognition for itself, playing to its name graphically. One side informs recipients about the firm and its capabilities—all accented by extreme close-ups and unusually cropped photos of oranges. The reverse side shows examples of the firm's work.

L'ORÉAL PROFESSIONAL
MAJIREL INTRODUCTION

Design Firm: Ana Couto Design
Art Director/Designer/Copywriter: Ana Couto Design
Photographers: L'Oréal archives, Ricardo Cunha, Lisley Cunha
Client: L'Oréal Professional

Paper Stock: Product book–Cover: Kraft 30 g/m², Text: Gloss Couché 150 g/m²,
Chocolate box: Kraft 240 g/m³
Printing: Product book–Cover: 1 over 1, Text: 4 over 5, offset,
Box–1 over 1, offset
Print Quantity: 3000

Ana Couto Design capitalized on the individual names of L'Oréal Professional's new hair colors—hazelnut, almond, chocolate, and cinnamon—with a collection of promotional materials targeted to beauty salons. The design team created a conceptual book that visually links each shade of hair color with the essence of its name, all of which made for some luscious product photography. To reinforce the message, boxes of chocolates were mailed to professional hair colorists, successfully increasing product awareness among its target buyers.

chocolate

O classicismo e a modernidade do legítimo marrom.

chocolate

Uma cor requintada
para delinear a
fisionomia feminina.

Majirel HT 6,34 - Louro Escuro Dourado Acobreado

HOLLIS DESIGN WEB SITE
www.hollisdesign.com

Design Firm: Hollis Design
Art Director/Copywriter: Don Hollis
Designers: Don Hollis, Heidi Sullivan
Photographer: Craig Tomkinson
Flash Programmer: John Dennis
Client: Hollis Design

Minimal graphics and icons reminiscent of the periodic table of the elements make this Web site especially intriguing and easy to navigate. Visitors are invited to take a pop-up studio tour that consistently emphasizes Hollis Design's capabilities. The site is both fun and informative, so it is not surprising that the site has averaged 2000 hits per month.

TOUCHSTONE EXHIBITIONS AND CONFERENCES BROCHURE

Design Firm: Trickett & Webb
Art Directors: Lynn Trickett, Brian Webb
Designers: Lyn Trickett, Brian Webb, Katja Thielen
Illustrator: Jeffrey Fisher
Client: Touchstone Exhibitions and Conferences
Printer: Ventura Litho

Paper Stock: Donside Consort Royal Silk
Printing: 4 colors, sheetfed
Print Quantity: 5000

Touchstone is a company that organizes exhibitions and conferences, so its services and capabilities do not offer dynamic visuals. Realizing this, Trickett & Webb didn't even try to find photos that would do the firm justice. Instead, they developed a brochure, called it a handbook, and used hands as the primary graphic throughout. Various hands may be an unusual choice, but here they symbolize the diversity of the company's work and approach, all of which the brochure's copy reinforced.

who we work with

Making a Sale

"If possible, include a sample in the sales piece. If that is not feasible, include an endorsement quote or story from a satisfied user."
—Morgan Shorey, The List®

Selling in today's world is both easier and more challenging than ever before. It's easier because so many venues are available to make a sale—the Internet, direct mail, telemarketing, and the old-fashioned storefront. Selling also is more challenging for the very same reasons. An enormous number of sellers exist, with comparable products and services all hunting down the same consumer.

During the late 1980s and early 1990s, a rash of new books appeared full of sales tips ranging from the use of unconventional weapons and tactics to how to close a sale in sixty seconds or less. Regardless of the recommended approach, all focused upon the primary sales stages—attention, interest, conviction, desire, and the close. Salespeople are trained to recognize the signs of the buyer's interest in a product or service. Next, they work to convince the prospect through logic and emotion that they have a need for the product or service. Some people argue that the emotional angle does not exist in corporate sales, but others differ. They argue that even the corporate buying side desires to achieve, to excel, and to win that promotion. Finally, there is the last step in the sales process, the close.

Successful direct-response marketing pieces recognize the importance of these steps and, as a result, are powerful sales tools. The successful ones do their job so well that they have the power to persuade a prospect to place a phone call with credit card at the ready, indicating not merely interest in the product or service, but the conviction that they need it. Internet sites even allow the buyer to close the sale independently. In the real world, depending upon the product or service, salespeople use the direct-response piece solely to establish prospects' interest and need; they develop conviction and the close in person.

In this chapter, you'll find examples of great sales pieces—selling everything from products and services to selling oneself to land a job. They show what you're getting. Some include samples. They all excel at salesmanship. Door-to-door selling is a thing of the past. Direct-response marketing has taken its place.

LEATHERMAN 1998 PRODUCT CATALOG

Design Firm: Hornall Anderson Design Works, Inc.
Art Directors: Jack Anderson, David Bates
Designers: David Bates, Lisa Cerveny
Illustrator: Jack Unruh
Photographer: Condit Studio
Copywriter: Leatherman Tool Group
Client: Leatherman Tool Group
Printer: Dynagraphics

Paper Stock: Neenah Environment Sedona Red 80 lb. cover, Signature Dull 100 lb. text
Printing: 6 colors plus varnish
Print Quantity: 68,000

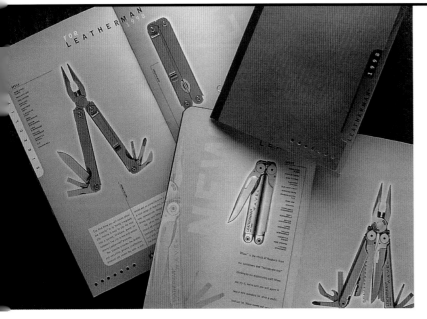

The Leatherman Tool Group manufactures those handy, multifunctional tools that allow you to do virtually everything, from install a ceiling fan and open a bottle of wine to daintily nibble an hors d'oeuvre—all with the same tool. Leatherman has a catalog that is equally multifunctional. Because the tools can do so much, the catalog could easily overwhelm, but it doesn't. Shoppers can easily find the information they need in its clean layout where the tool dominates.

COLE-HAAN PERFECT GIFTS TO
GIVE AND GET BROCHURE

Design Firm: RBMM
Art Director/Designer: Tom Mynus
Photographer: Jeff Stephens
Copywriter: Rob Baker
Client: Cole-Haan
Printer: Williamson Printing Corporation

Paper Stock: Mead, offset enamel, 80 lb. cover
Printing: 8 over 8, sheetfed
Print Quantity: 50,000

Some product catalogs are so packed with products that even the most interested buyers find it difficult to locate what they want. This accordion-folded, eight-panel, pocket-sized catalog mailer from Cole-Haan is just the opposite. Eleven gifts, "Perfect to Give and to Get," as the title tells us, are showcased in large photos, rich in detail. The presentation is thoroughly organized, down to the photographic backgrounds that alternate in order between pale shades of green, gray, and gold.

The copy includes a catchy one-line intro, and the product descriptions are equally concise. One headline echoes the overall objective of the piece, "You make the call." Given the straightforward approach of this mailer, its success during a hectic holiday season is no surprise.

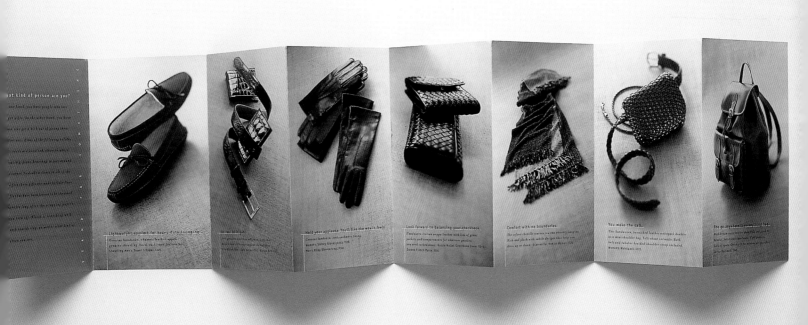

NANCY MORAN PHOTOGRAPHY PORTFOLIO

Design Firm: RBMM
Art Director/Designer: Tom Nynas
Photographer: Nancy Moran
Client: Nancy Moran Photography
Printer: Brodnax

Paper Stock: Potlatch Vintage
Printing: 4 over 1, sheetfed
Print Quantity: 10,000

This exquisite portfolio showcases the various works and styles of photographer Nancy Moran and generated a lot of requests for more information. Why is easy to see. The mailer arrives in an understated envelope. Inside, the contents, wrapped in a wide bellyband, tell the story of Nancy Moran. But the real story of this photographer is told in the sixteen enclosed postcards. They feature photographic images of every subject imaginable, from Vietnam refugees and a member of the IRA in Ireland to giggling teenage girls attending their senior prom. Black-and-white and color photographs, both posed and candid, clearly demonstrate Nancy Moran's range in a way that no ordinary mailer could.

ANDREW JANNETTI & DANCERS BROCHURE

Design Firm: SuZen Creations
Designer/Illustrator: SuZen
Photographer: Susan Clark
Client: Andrew Jannetti & Dancers
Printer: Century Copy Center

Paper Stock: 80 lb. white gloss
Printing: 2 colors, offset
Print Quantity: 5000

The simplicity and unique blend of romance and dance of this piece raise it above the clutter in a routine day's mail. Titled "Love Songs for the End of the Century," the brochure blurs the dancers, tricking the eye to believe they are actually in motion. The graphics are clean, and the critical reviews are concise. By the time readers arrive at the far-right inside panel, they are ready to contact the box office.

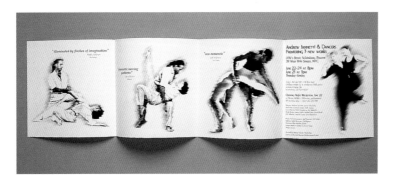

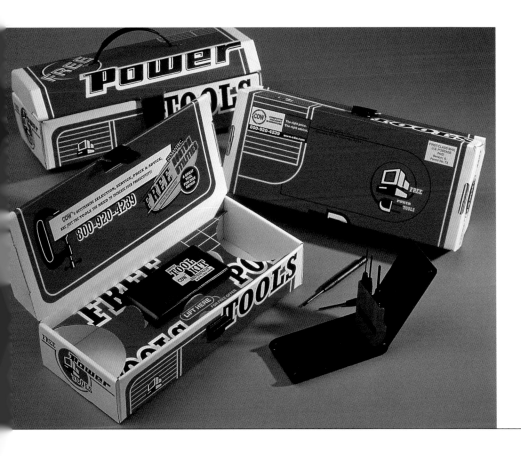

CDW COMPUTER CENTERS INC.,
"FREE POWER TOOLS" MAILING

Design Firm: Sayles Graphic Design
Art Director/Designer/Illustrator: John Sayles
Copywriter: Wendy Lyons
Client: CDW Computer Centers Inc.

Paper Stock: Fortune Matte text
Printing: 3 colors, offset, laminated to corrugated
Print Quantity: 30,000

Eye-stopping red graphics emblazoned on a toolbox-shaped, corrugated box dominate this mailer from Computer Discount Warehouse (CDW). Inside the box, recipients found "Free Power Tools" that included a miniature computer-repair kit, a product catalog, and an offer for disk-repair software. The idea that CDW is a valuable tool for solving all types of computer challenges proved to be a winner. Sales directly attributed to the mailer surpassed CDW's goals by 30 percent.

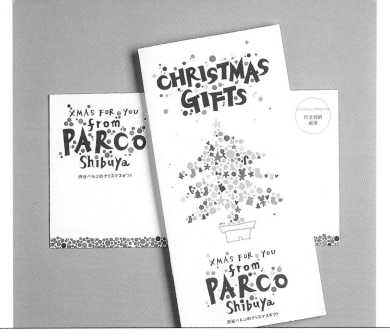

PARCO CHRISTMAS CATALOG

Design Firm: Kenzo Izutani Office Corporation
Art Director: Kenzo Izutani
Designers: Kenzo Izutani, Aki Hirai
Illustrator: Aki Hirai
Photographer: Yusuyuki Amazutsumi
Copywriter: Reiko Nagahara
Client: Parco Co., Ltd.
Printer: Dainippon Printing

Paper Stock: New Age
Printing: 4 colors, offset

The relatively small size of this catalog, coupled with the number of product photos, might seem to make matching products to a Christmas want-list difficult, but it doesn't. The designers categorized product pages for women, men, and teens, which makes the catalog an easy reference guide for finding the perfect gift. By reducing its bulk almost to the size of a pamphlet and by integrating bright colors in an airy, random pattern, the designers have separated this catalog from the crowd.

Design Firm: Mires Design, Inc.
Art Directors: Scott Mires, Neill Archer Roan, Laura Hull
Designer: Miguel Perez
Illustrators: Jody Hewgill, Mark Ulriksen
Copywriter: Neill Archer Roan
Client: Arena Stage
Printer: Peake Printers

Paper Stock: Gilbert Realm
Printing: 4-color process plus 1 PMS color and varnish, web
Print Quantity: 250,000

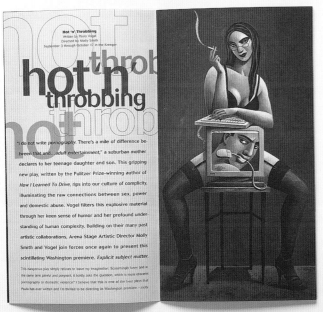

Mires Design showcased Arena Stage's 1999–2000 offerings and captured an entire season's plays in one catalog. Original illustrations unify the plays with a common theme, avoiding a disjointed appearance that makes similar pieces look busy and cluttered. The illustrations are hip and the color palette is the perfect complement. By the time subscribers reach the end of the catalog, they are ready to sign up, and many did. According to Mires Design, Arena Stage exceeded previous sales figures after the catalog's debut.

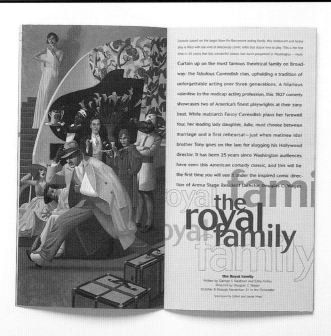

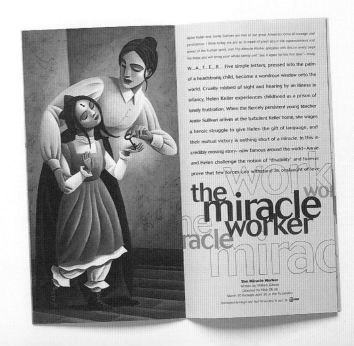

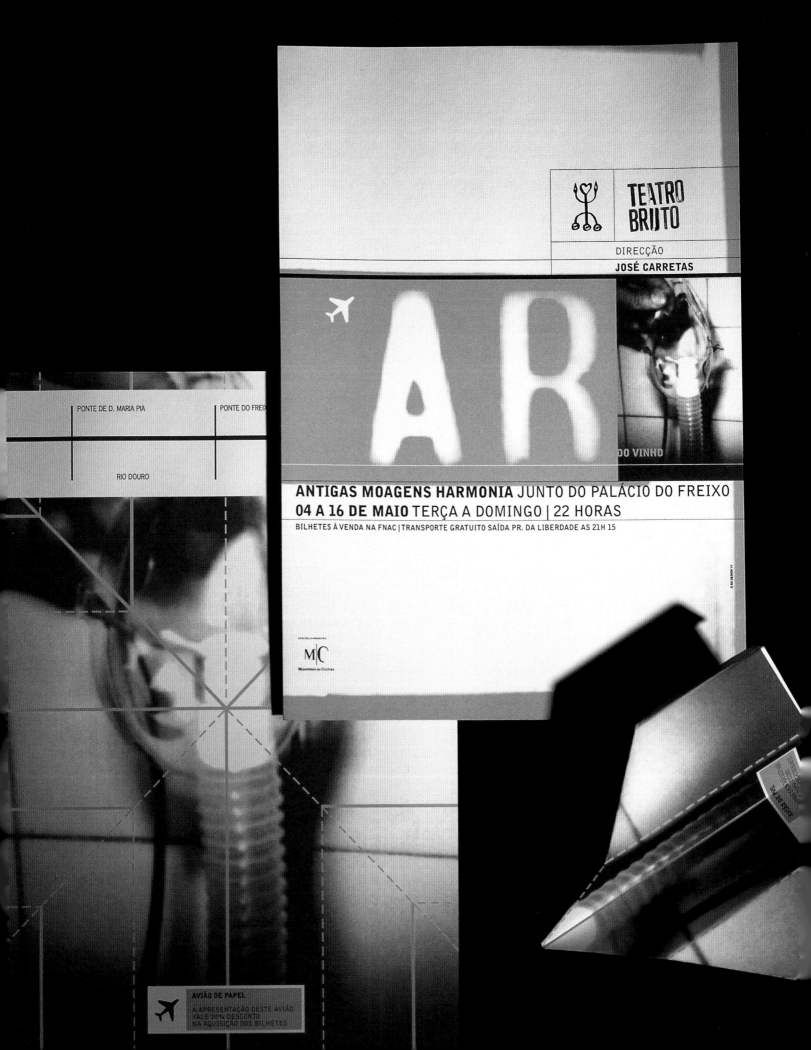

TEATRO BRUTO AIR FLYER AND BROCHURE

Design Firm: R2 Design
Art Directors/Designers: Lizá Defossez Ramalho, Artur Rebelo
Client: Teatro Bruto
Printer: A. Moreira & Filhos, Lda.

Paper Stock: Flyer—IOR 150 g.,
Brochure—Kraft card stock and adhesive glossy paper
Printing: 2 colors, offset
Print Quantity: Flyer—2000, Brochure—400

To generate excitement and ticket sales to a theatrical event, R2 Design used the concept of air and took the idea of a flyer to the extreme, blurring the typography to further the illusion of air and constructing the flyer as a paper airplane. The humorous approach paid off. Attendance was good. More important, people saved the flyer. They sent their paper planes in the air throughout the theater before the play began.

Design Firm: Formgefühl
Art Director/Copywriter: Marius Fahrner
Client: Marius Fahrner
Printing: Canon Color Laser Copier

In this instance, making a sale means landing a job. Marius Fahrner, a graphic-design student, prepared this multipiece direct mail to showcase his talents to design studios and, at the very least, to win an opportunity to show his portfolio. Working with a tight budget, Fahrner used a combination of stock photography and Polaroid images, and he printed everything on a laser copier. The mailing began with the teaser card. The other items soon followed. According to Fahrner, the pieces parallel his personality, but he was careful to avoid appearing too small or trivial in order not to dissuade prospective employers looking for someone who thinks big.

MARIUS FAHRNER CD-ROM SELF-PROMOTION

Design Firm: Formgefühl
Art Director/Copywriter: Marius Fahrner
Client: Marius Fahrner
Printing: Canon Color Laser Copier

Selling yourself can be a challenge, particularly when it comes down to winning your dream job or settling for something less. In this self-promotion, Marius Fahrner suggested to prospective design studios that his talents offer a "new level of graphic design," playing off an airline theme on a CD-ROM self-promotion. His story starts at the check-in, and as the readers open flaps of the CD jacket, they seemingly travel through the airport, finally ending up at the takeoff, which is the starting point of the CD. The black-and-white photography is stylized and often blurred to simulate the wind produced by the airplane. In the end, Fahrner's efforts paid off and he landed the job. He has subsequently opened his own studio, Formgefühl.

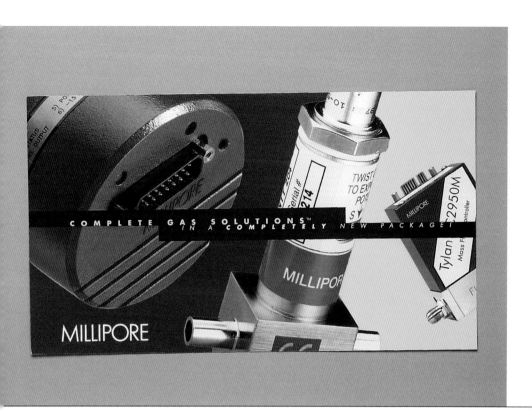

Design Firm: Stewart Monderer Design, Inc.
Art Director: Stewart Monderer
Designer: Joe LaRoche
Photographer/Copywriter: Millipore
Client: Millipore
Printer: Pride Printers

Paper Stock: Coated 100 lb. cover
Printing: 4-color process and spot varnish, offset
Print Quantity: 30,000

Designed with bold primary colors, this oversized postcard cleanly communicates
that Millipore's products now sport completely new packaging. The design on the
reverse takes a more subtle approach, but no less effective. The card provides
plenty of room for copy, along with four product shots set off from the yellow
background with black borders that give the graphics a bold, contemporary feel.

SIERRA SUITES
EXTENDED-STAY DIRECT MAIL

Design Firm: Greteman Group
Art Directors: Sonia Greteman, James Strange
Designer: James Strange
Copywriter: Deanna Harms
Client: Sierra Suites Hotel Company
Printer: PrintMaster

Paper Stock: Corrugated cardboard boxes, MACtac pressure-sensitive labels
Printing: 2 colors, silk-screened, offset
Print Quantity: 2000

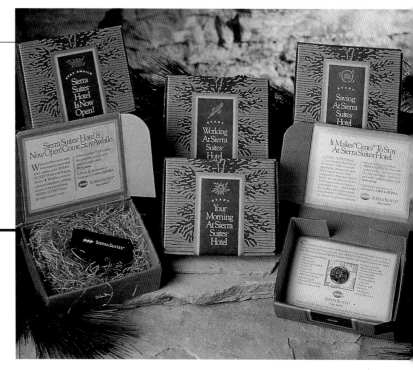

The Sierra Suites Extended-Stay Hotel was booked to capacity for its opening week following this four-part object mailing that announces the grand opening and touted the hotel's many features. Inexpensive gifts, including oatmeal packets and Post-It notes, were packaged in premade corrugated boxes that were labeled (to contain costs) rather than printed with two-color graphics. The simple green and earth-tone colors and conversational copy communicate the relaxed informality of the hotel.

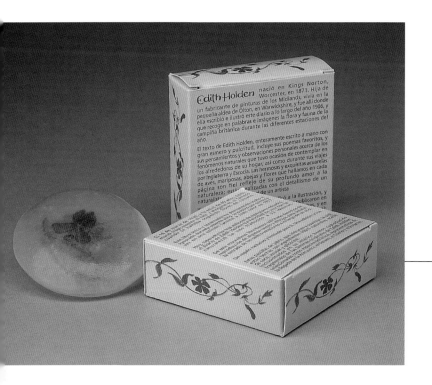

PROCLINIC'S EDITH HOLDEN FOUR SEASONS

Design Firm: Producciones Osoxile S.L.
Art Director/Designer: Carmelo Hernando
Illustrator: Licensed by Copyrights Europe. *The County Diary of an Edwardian Lady*
Client: Proclinic

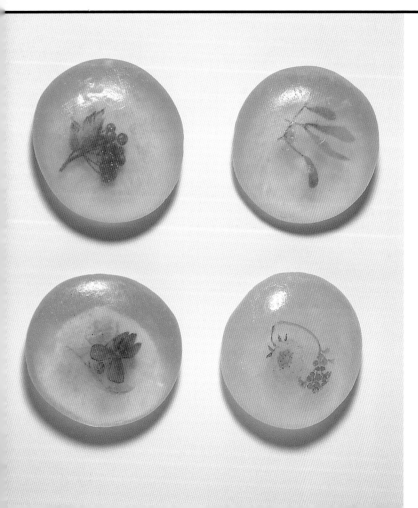

Called "Edith Holden Four Seasons," this incentive mailing campaign from Proclinic aimed to increase the loyalty of clinic assistants, and subsequently, to increase sales. The campaign targets prospects' emotions. It began with an offer to get to know the Edith Holden Four Seasons story. Those who didn't respond received a follow-up telephone call. Next, floral-designed boxed soaps were mailed, one per season throughout the year. Loyal customers were rewarded with an even more enduring thank you, framed illustrations of the seasonal artwork. The eleven-month campaign generated a positive response that exceeded 52 percent and resulted in significantly increased sales.

DUFFINS GAME MAILER

Design Firm: Greteman Group
Art Directors: Sonia Greteman, James Strange
Designers: James Strange, Sonia Greteman, Jo Quillin
Copywriters: Deanna Harms, Rayma Essex
Production Artist: Jo Quillin
Client: Duffins
Printer: Donlevy Lithograph

Paper Stock: Aqueous-coated gloss enamel
Printing: 4 colors, offset and silk-screened
Print Quantity: 10,000

Greteman Group designed this full-scale game board and pieces, rendered in sophisticated shades of purple, turquoise, black, and khaki, as a sales incentive. Designers created graphics and illustrations for the project in lieu of more expensive photography. The game approach was fun, but the goal—generating sales—was serious business. Was it successful? During a quarter when other lens companies endured flat sales, Duffins profited.

FIFTY-TWO REASONS TO OWN A LEARJET
DIRECT MAILER

Design Firm: Greteman Group
Art Directors: Sonia Greteman, James Strange
Designer/Illustrator: James Strange
Copywriters: Nita Scrivner, Sonia Greteman
Production Artists: Jo Quillin, Todd Gimlin
Client: Learjet
Printer: Donlevy Lithograph

Paper Stock: Litho Label, playing-card stock
Printing: 4 colors, offset
Print Quantity: 5000

Does anyone need fifty-two reasons to own a Learjet? Learjet thinks so and asked Greteman Group to create a combination mailer/leave-behind that would generate sales leads and tout the advantages of owning a Learjet 45, a new business jet. A custom-designed deck of playing cards provided ample room to enumerate fifty-two distinct reasons to make the purchase. Interested buyers better hurry to the phone because this mailer increased sales so much that Learjet now is taking backorders. The approximate wait time? Several years.

SALISBURY PEWTER POSTCARD

Design Firm: Whitney Edwards, LLC
Art Director: Charlene Whitney Edwards
Designer: Barbi Christopher
Client: Salisbury Pewter
Printer: Economy Printing

Paper Stock: Cornwall C1S 8 pt. cover
Printing: 4 over 1, offset
Print Quantity: 10,000

One doesn't tend to associate pewter with space-age graphics, but in this case, the unorthodox association worked to promote pewter for the new millennium. The simple postcard generated a "greater-than-expected response from the retailers," according to Charlene Whitney Edwards.

KEVIN KAPIN MANUFACTORY
JEWELRY BELLS CATALOG

Design Firm: Belyea
Art Director: Patricia Belyea
Designer: Adrianna Jumping Eagle
Photographer: Terry Reed
Copywriter: Patricia Belyea
Client: Kevin Kapin Manufactory
Printer: GAC/Allied Printers

Paper Stock: Lustro Gloss 80 lb. cover
Printing: 4-color process, sheetfed
Print Quantity: 4000

Kevin Kapin Manufactory makes a line of silver jewelry bells targeted to retailers. This comprehensive direct-mail catalog not only shows the entire line of 100 jewelry bells, but each is shown at actual size to give buyers the best possible presentation in lieu of a personal sales call. Surprisingly, all the photography was accomplished in one long day to keep costs within budget. The images have an almost three-dimensional quality to them. When integrated with the thin, rectangular format of the catalog, rich green and white backgrounds, and choice of typestyle, a very distinctive catalog results. The mailing also included a price list, and as an added bonus, details of an incentive program.

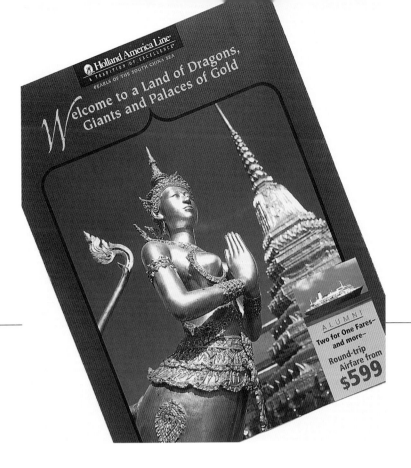

HOLLAND AMERICA BROCHURE

Design Firm: Belyea
Art Director: Patricia Belyea
Designer: Christian Salas
Photography: Stock images
Copywriters: Charlie Ernst, Liz Holland
Client: Holland America
Printer: GAC

Paper Stock: Mead Gloss 80 lb. book
Printing: 4-color process, web
Print Quantity: 1000

Belyea was asked to design a brochure that would sell 500 bookings on a cruise that had already been promoted three times before with little success. Acknowledging that the key to the brochure's success would be its photography, Belyea launched an extensive search of stock photos for just the right images. It worked. Three weeks after the brochure was mailed, recipients booked 474 cruises.

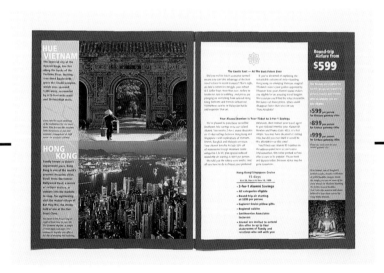

FLOSPORT/SLANT-SIX CLOTHING INC.
BROCHURE

Design Firm: Orange
Art Director/Designer: Susan Lee
Photographer: Verve Photographics
Client: Flosport/Slant-Six Clothing Inc.
Printer: Generation Printing

Paper Stock: Karma Dull
Printing: 4-color process and varnish, offset
Print Quantity: 5000

Orange designed this image brochure to generate interest among retail buyers in Flosport's new season's line of sportswear. At first glance, it comes as little surprise to learn the target market is women ages fourteen to twenty-two. The graphics are edgy and urban with a lot of visual appeal for young audiences. Orange used the theme to create trade-show presence, where sales increased by 25 percent over the previous year.

RSA

Design Firm: Trickett & Webb
Art Directors: Lynn Trickett, Brian Webb
Designers: Lynn Trickett, Brian Webb, Heidi Lightfoot
Photographer: Mel Yates
Client: The Royal Society of Arts
Printer: Ventura Litho

Paper Stock: Classic Triple Silk
Printing: 5 colors, sheetfed litho
Print Quantity: 15,000

Often the key to a successful catalog sale is not to overwhelm the buyer with too many choices. This catalog from the Royal Society of Art presents only a handful of items for sale. Even though they are quite affordable, each seems singularly appealing, as if it were a rare and expensive item. This perception alone can inspire purchases from buyers who think they couldn't possibly afford something so beautiful but then discover, to their amazement, that they can.

TOKUSHU PAPER MANUFACTURING CO. LTD.
"BORN FREE" STOCK SELECTOR

Design Firm: Kan & Lau Design Consultants
Art Director: Kan Tai-Keung
Designers: Kan Tai-Keung, Eddy Yu Chi Kong, Leung Wai Yin
Photographer: CK Wong
Computer Illustrators: Benson Kwun-Tin Yau, Leung Wai Yin, John Tam Mo Fai
Calligraphers: Chui Tze Hung, Yung Ho Yin
Chinese Ink Illustrator: Kan Tai-Keung
Engrave Seal Characters: Yip Man Yam
Client: Tokushu Paper Manufacturing Co. Ltd.
Printer: Sun Rise Printing Co.

Paper Stock: Cover—Bornfree Warm White 118 gsm,
Text—Bornfree Recycled Paper 116 gsm
Printing: Cover and Image Pages—4 colors and 2 special colors,
Swatches—2 over 2, offset, embossed, hot-stamped
Print Quantity: 5000

Designers are accustomed to exquisite swatch books; if they don't look magnificent, one doubts how well the paper will reproduce when it counts. This stock selector is no exception. The stock is certainly unique, with a feel and texture more closely resembling fabric than paper. This feeling of luxury and distinction is reinforced by the graphics chosen for the stock selector. The graphics are part watercolor and part photography, all of which are accented with bold calligraphy, die-cuts, embossing, and foil-stamping.

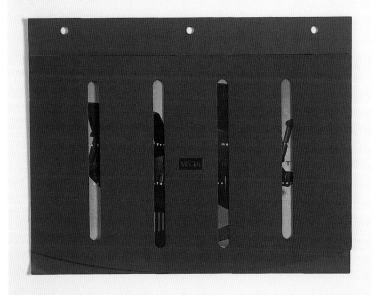

VECTA KART CHAIR BROCHURE

Design Firm: 5D Studio
Art Director: Jane Kobayashi
Designer: Geoff Ledet
Illustrator: IDEO
Photographer: Pete McArthur
Copywriter: Audrey Schiff
Client: Vecta
Printer: Lithographix

Paper Stock: Curtis Tweedweave Black 100 lb. cover, Vintage Gloss 100 lb. book
Printing: 6 over 6, plus aqueous coating, sheetfed
Print Quantity: 15,000

When Vecta introduced the Kart, the first task chair that could be nested for easy storage, the firm needed a brochure that could be inserted into existing company sales binders. Perhaps more important, the firm also wanted the brochure to demonstrate clearly the chair's innovative design. The resulting piece from 5D Studio features a black die-cut cover that resembles the slat back of the chair, while the bottom curve of each page mimics its shape. This eye-catching treatment only serves to enhance the colorful photography, the centerpiece of which is the brochure's prime selling point, a horizontal photo showing the chair's primary feature—compact storage.

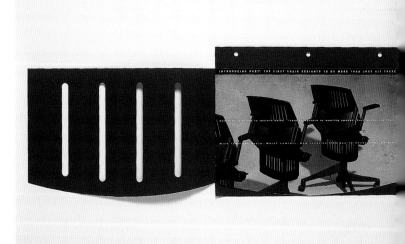

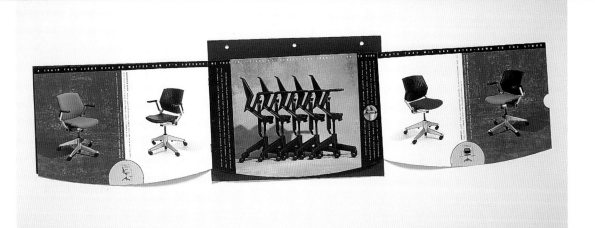

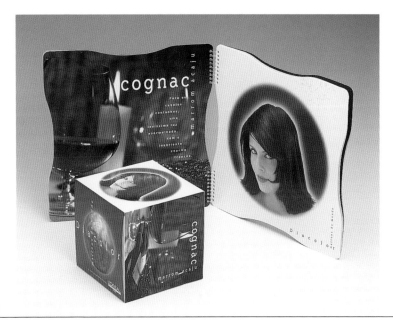

L'ORÉAL PROFESSIONAL DIACOLOR PROMOTION

Design Firm: Ana Couto Design
Art Direction/Design/Copywriting: Ana Couto Design
Photographers: L'Oréal archives, Ricardo Cunha, Lisley Cunha
Client: L'Oréal Professional

Paper Stock/Printing:
Product Book: Cover—300 g/m², silk-screened, Text—Gloss UV Varnish 240 g/m², 5 over 5, offset
Postcards: Triplex cardboard 150 g/m², 5 over 4, offset
Cube Display: Varnish cardboard 200 g/m², 5 over 5, offset
Print Quantity: Product Book—3000
Postcards—5000 each of 4
Cube Display—5000 each of 4

To generate recognition and sales for this line of hair color, Ana Couto Design associated each shade—coffee, cognac, cappuccino, and chocolate—with a different country. The promotional brochure and packaging all follow the same format: the coffee woman is Brazilian, the cognac woman is French, the cappuccino woman is Italian, and the chocolate woman is Swiss. The matching postcards allowed the trade to communicate directly with clients and to provide a casual yet ongoing product reminder.

Requesting Information and Donations

"Make it easy. People discard return reply materials because it takes time out of their day. Preprint the survey or donation form with the recipient's name, address, and other pertinent information. Make it a fax-back form. Don't make them look for a stamp and an envelope. Make all their responses simple—check boxes, simple two-to-five word answers, etc. Don't ask them to write an essay."
—Morgan Shorey, The List®

To motivate people to do something in return for feeling good is a lofty pursuit—and a difficult one.

We ask people to complete a survey or fill out a form so that *we* can do our jobs better. We implore them to make financial contributions so that we can continue our nonprofit efforts. We remind them to donate blood so that *others* can live. Amid the tumult of all these requests, the recipient often gets lost while wondering, "We, We, We. What about *me?*"

When asking individuals to give so much of themselves with so little given back in return, the message must be framed appropriate to the situation. It must appeal to their sense of helpfulness, accomplishment, or the sense that in some small way, their giving does some good.

These feelings must be cultivated, nurtured, and presented visually to appeal to the altruism in all of us. They take many forms—lighthearted, heartfelt, solemn, and entertaining.

Whatever the tone, encouraging people to give their time, their money, or themselves is serious business, especially where monetary donations are concerned.

Today's fundraising efforts have taken on a new patina in order to reflect that selflessness sometimes requires an incentive. To build attendance at events, door prizes are bigger, celebrities are present, and desirable settings are compulsory. To encourage people to complete a survey, humor is essential. Whatever the request, these pieces succeed because, in addition to everything else they do right, they make it easy to respond and to give.

This chapter includes examples that make use of all these techniques, sure to make givers of us all.

Design Firm: Lambert Design
Art Director/Designer/Copywriter: Scott Lambert
Client: Spicers Paper
Printer: Coast Litho

Show us your best.

Fraser Papers (they make the paper) and Spicers Paper (they stock the stuff) encourage you to send in all your best designs that were printed on any of these Fraser Papers products: Passport, Genesis, Synergy, Outback, Glacier, Torchglow and Halopaque.

So go ahead, be recognized.

Paper Stock: Synergy Smooth White 80 lb. cover
Printing: 4 colors, offset
Print Quantity: 8000

Anyone who has ever worked hard on a project and then not received even a mumbled thank you can relate to this series of three mailers, sent two weeks apart, requesting samples of designs printed on Fraser paper stocks. Designer Scott Lambert used humor and stock photos to create scenarios of the pains that designers suffer when creating their best work. The copy gets right to the point: We'll recognize you, even if no one else will. The concept exceeded all expectations, according to Lambert. Sixty-two percent of those receiving the mailings responded with entries.

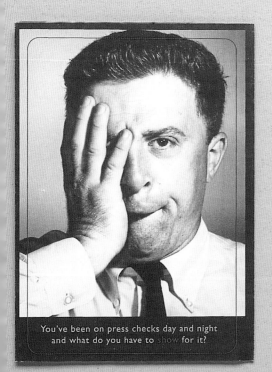

You've been on press checks day and night and what do you have to show for it?

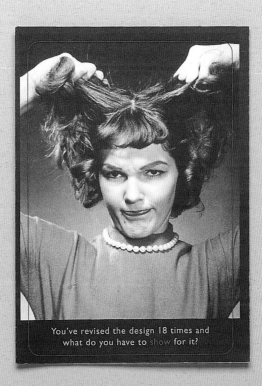

You've revised the design 18 times and what do you have to show for it?

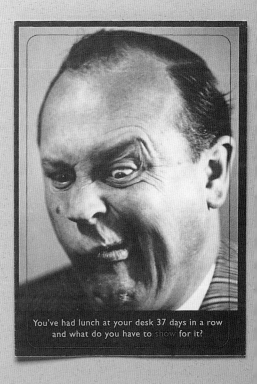

You've had lunch at your desk 37 days in a row and what do you have to show for it?

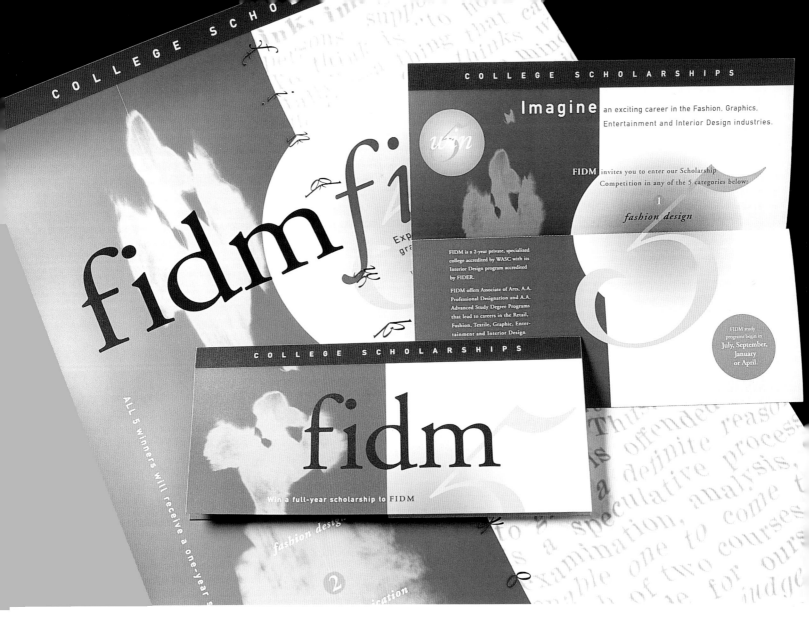

FASHION INSTITUTE OF DESIGN AND MERCHANDISING SCHOLARSHIP BROCHURE

Design Firm: Vrontikis Design Office
Art Director/Designer: Petrula Vrontikis
Photographer: Scott Morgan
Client: Fashion Institute of Design and Merchandising (FIDM)
Printer: Donahue Printing

Paper Stock: Potlatch Vintage Velvet
Printing: 4-color process plus 2 metallic inks and varnish, sheetfed
Print Quantity: 8000

The landscape orientation of this brochure that calls for entries to win a scholarship to FIDM maximizes graphic impact and provides plenty of room to itemize in detail the five categories of contention. The design is clean and the color palette upscale. Interestingly, the entry form makes use of a full panel versus the most traditional standard three-by-five-inch reply card size. The result is an expansive entry that drives home the message that it should be "mailed today." In all, this brochure is a fitting approach for an institution that specializes in design and areas of visual communication.

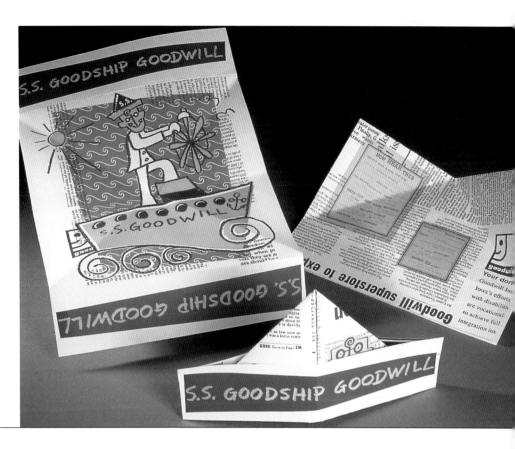

GOODWILL INDUSTRIES
"GOODSHIP GOODWILL" INVITATION

Design Firm: Sayles Graphic Design
Art Director/Designer/Illustrator: John Sayles
Copywriter: Annie Meacham
Client: Goodwill Industries of Central Iowa

Paper Stock: Finch opaque and vellum
Printing: 3 colors, offset
Print Quantity: 1600

"Goodship Goodwill" was the theme for this inaugural fundraiser that used nautical graphics for everything from the invitation, posters, and raffle tickets to its signage. John Sayles designed the invitation with a collage of newspaper clippings about Goodwill Industries. He used an oversized sheet folded in the shape of a paper hat, which was then mailed in a glassine envelope. A limited-edition poster was sold to raise additional funds. When the evening was over, the event had raised more than $18,000 for charity.

Careers / Application

Magna believes that every employee should own a portion of the company.

CAREERS
CONTACT US
MAGNA HOME

Job Categories
Accountant

Date available to begin work
07/13/99

Personal Data

Last name Given name

Are you legally eligible to work in the United States?
○ Yes ○ No

Apt. Number Address

Are you legally eligible to work in Canada?
○ Yes ○ No

Are you willing to re-locate?
○ Yes ○ No

City

Are you between the ages of 18 and 65 years of age?
○ Yes ○ No

State/Province Country Postal/Zip Code

Are you willing to work shift work?

Home Telephone Business Telephone

MAGNA INTERNATIONAL WEB SITE
www.magnaint.com

Design Firm: Yfactor, Inc.
Art Director: Anya Colussi
Client: Magna International

The clean, high-tech appearance of this Web site is geared to generate responses from investors as well as from potential employees. Magna's financial growth and activity are expertly detailed with press releases that aren't merely posted on the site, but also are integrated into the layout for easy access and readability. With quality employees harder than ever to find, the career section is equally important and posts job listings from around the world. If a particular job catches a visitor's interest, he or she can access a general application form at a click of a button.

Careers

Go Places

IN BRIEF
INVESTORS
NEWS
PRODUCTS
CAREERS
OUR CULTURE: MAGNA'S CORPORATE CONSTITUTION
FOUNDATION: THE MAGNA EMPLOYEE'S CHARTER
GROUPS
CONTACT US
SITE MAP
HOME

Magna, one of the most diversified automotive suppliers in the world, designs, develops and manufactures automotive systems, assemblies and components and engineers and assembles complete vehicles, primarily for sale to original equipment manufacturers of cars and light trucks in North America, Europe, Mexico and South America.

Magna has over 51,000 employees in 162 manufacturing operations and 29 product development and engineering centres in 18 countries.

SUBMIT GENERAL APPLICATION

Positions Available

CAREERS BY POSITION TITLE
CAREERS BY LOCATION
CAREERS BY DATE POSTED
SEARCH

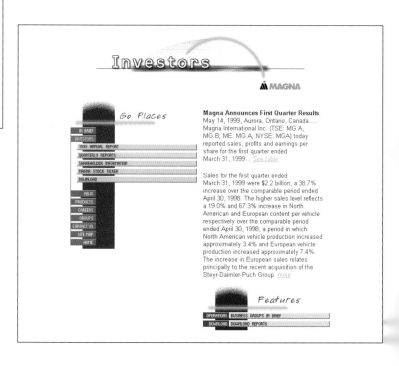

Investors

Go Places

IN BRIEF
INVESTORS
1998 ANNUAL REPORT
QUARTERLY REPORTS
SHAREHOLDER INFORMATION
MAGNA STOCK TICKER
DOWNLOAD
NEWS
PRODUCTS
CAREERS
GROUPS
CONTACT US
SITE MAP
HOME

Magna Announces First Quarter Results
May 14, 1999, Aurora, Ontario, Canada.....
Magna International Inc. (TSE: MG.A, MG.B; ME: MG.A; NYSE: MGA) today reported sales, profits and earnings per share for the first quarter ended March 31, 1999... See table

Sales for the first quarter ended March 31, 1999 were $2.2 billion, a 38.7% increase over the comparable period ended April 30, 1998. The higher sales level reflects a 19.0% and 67.3% increase in North American and European content per vehicle respectively over the comparable period ended April 30, 1998, a period in which North American vehicle production increased approximately 3.4% and European vehicle production increased approximately 7.4%. The increase in European sales relates principally to the recent acquisition of the Steyr-Daimler-Puch Group. more

Features

OPERATIONS BUSINESS GROUPS IN BRIEF
DOWNLOAD DOWNLOAD REPORTS

Design Firm: Pepe Gimeno – Proyecto Gráfico
Designer: Pepe Gimeno
Copywriter: Manuela Rabadán
Client: Feria de Valencia

Paper Stock: Torras Papel Ikonofix Special Matt 150 g.
Printing: 4 colors, offset
Print Quantity: 70,000

As an invitation to the thirty-fifth International Furniture Fair of Valencia, Spain, this mailer, the second in a series of three, serves a dual purpose. It gives information—several reasons for attending the event, including plenty of parking "ready and waiting." It also requests information—the reply card asks recipients for a great deal of information about themselves. The result is a simple piece that works hard, so hard, in fact, that the 70,000 mailers that were printed generated 60,000 responses.

Race Judicata
Chicago Volunteer Legal
Services Foundation
100 North LaSalle Street
Suite 900
Chicago, Illinois 60602-2400

0:00

CHICAGO VOLUNTEER LEGAL SERVICES
RACE JUDICATA MAILER

Design Firm: Lowercase, Inc.
Art Director/Designer: Tim Bruce
Copywriters: M. Lee Witte, Margaret C. Benson
Client: Chicago Volunteer Legal Services
Printer: Dupligraphics

Paper Stock: French Durotone Butcher Paper 70 lb. text
Printing: 2 PMS colors and varnish, offset
Print Quantity: 2000

To encourage sponsorship of this five-kilometer run/walk, Lowercase, Inc. prepared a mailer that played up the race theme with a distinctive stopwatch visual. The zero-hour readout appears first on the envelope. Inside, it starts counting down from fifteen minutes, twenty-three seconds. This visual tool, coupled with the low-resolution treatment of the photos, gives the piece a sense of urgency.

15min23sec

**Chicago Volunteer Legal Services
PRESENTS
race
Judicata®
5K RUN/WALK
98**

Last **August 14,**
1,300 people ran

CORBIS 1997 BETTMANN CATALOG

Design Firm: Hornall Anderson Design Works, Inc.
Art Director: Jackson Anderson
Designers: Jack Anderson, John Anicker, Mary Hermes, Margaret Long
Photographer: Corbis archive
Copywriters: Matthaeus Halverson Ayriss Advertising, Corbis Corporation
Client: Corbis Corporation
Printer: Grossberg Tyler

Paper Stock: Neenah Classic Columns Red Pepper 80 lb. cover, Vintage Velvet Remarque Book White 100 lb.
Printing: 4 colors plus 1 PMS color, and varnish, offset, foil-stamped
Print Quantity: 30,000

Hornall Anderson Design Works, Inc. created this catalog to list Corbis's archival images, an incredible array of visuals that allows the reader to time-travel through history, current events, and pop-culture icons. As a catalog, it excels at the soft sell; as a direct-mail piece, it is a master sales tool. Recipients cannot mistake Corbis's Web-site address embossed on the front cover or its toll-free order number foil-stamped on the back. If these elements alone don't make response easy, then the two business-reply cards and the perforated Rolodex card inside the back cover do.

WILLIAMSON PRINTING CORPORATION
ANNUAL REPORT QUESTIONNAIRE

Design Firm: Eisenberg & Associates
Art Director: Sol Torres
Designer/Illustrator/Copywriter: Larry White
Photographer: Dick Patrick
Client: Williamson Printing Corporation
Printer: Williamson Printing Corporation

Paper Stock: Mohawk Superfine 80 lb. cover
Printing: 6 over 6, sheetfed
Print Quantity: 9000

"You can trust us." That's the message of this simple mailer, created with humor and images with which anyone can identify. In this case, the message was sent to corporations and designers seeking a printer to handle their annual report. Prospective clients who received this mailing from Williamson Printing were asked to grade their satisfaction with the printing of their last annual report and to mail their responses. In turn, Williamson contacted respondents directly. The result— Williamson's annual-report season was larger than ever.

A successful annual report relies on

TRUST

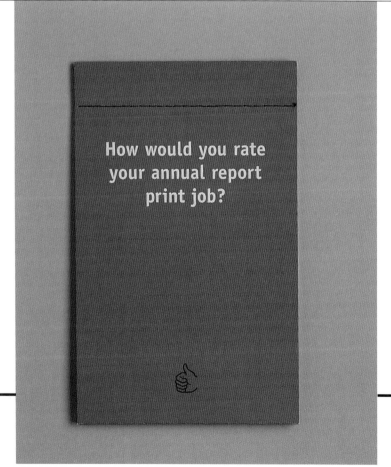

WILLIAMSON PRINTING CORPORATION
ANNUAL REPORT CARD

Design Firm: Eisenberg & Associates
Art Director: Sol Torres
Designer: Meggan Webber
Photographer: Dick Patrick
Copywriter: Arthur Eisenberg
Client: Williamson Printing Corporation
Printer: Williamson Printing Corporation

Paper Stock: Rubicon 80 lb. cover, Kromecote C1S 8 pt. cover, Rubison Smooth 80 lb. cover, Starwhite Vicksburg Tiara 80 lb. cover
Printing: Cover—7 over 2, Cards—6 over 1, sheetfed
Print Quantity: 6000

Gene Siskel and Roger Ebert made their thumbs-up/thumbs-down rating system famous, and here, the same format is applied to grading the success (or lack there-of) of an annual-report print job. The tactic uses the familiar graphic in various stages of health—from a vigorous thumbs-up, to a bandaged thumb, and finally, a broken hand in a cast, the latter indicative of a painful experience. Each photo is actually a perforated business-reply postcard that those seeking an alternative printer for their annual reports can easily complete in five seconds.

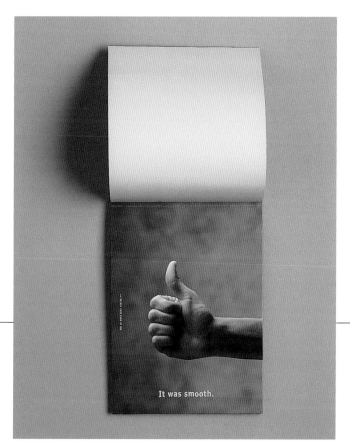

It was smooth.

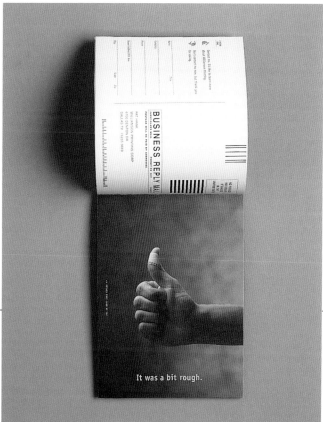

It was a bit rough.

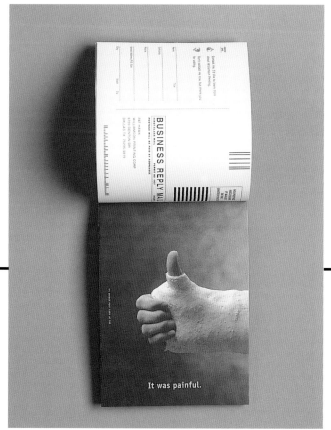

It was painful.

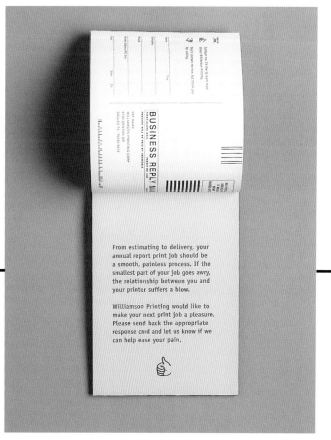

From estimating to delivery, your annual report print job should be a smooth, painless process. If the smallest part of your job goes awry, the relationship between you and your printer suffers a blow.

Williamson Printing would like to make your next print job a pleasure. Please send back the appropriate response card and let us know if we can help ease your pain.

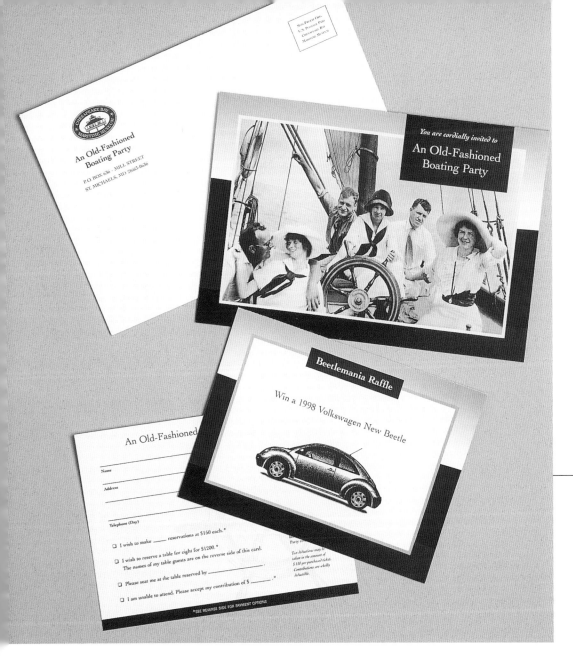

CHESAPEAKE BAY MARITIME
MUSEUM INVITATION

Design Firm: Whitney Edwards, LLC
Art Director: Charlene Whitney Edwards
Designer: Barbi Christopher
Client: Chesapeake Bay Maritime Museum
Printer: Economy Printing

Paper Stock: Vintage Velvet White Coated 80 lb. cover
Printing: 2 PMS colors, offset
Print Quantity: 5000

The nautical color palette of this multipiece invitation to a membership-boosting event not only complements the party theme, but also inspires feelings of nostalgia for those times. The event generated enough interest that the museum filled its membership quota almost immediately.

Even without water for a moment is hard to bear. Just imagine what will happen if we are short of blood

血 濃 於 水　　永 遠 需 要 你 捐 血

THE HONG KONG RED CROSS
BLOOD-DONATION POSTCARD

Design Firm: Kan & Lau Design Consultants
Art Director/Designer: Kan Tai-Keung
Client: The Hong Kong Red Cross

Paper Stock: Single-side art card 300 gsm.
Printing: 4-color process plus 1 spot color, offset
Print Quantity: 2000

This postcard appears to promote an upcoming art show, but upon closer inspection, one can see that it is a call for blood donation from the Hong Kong Red Cross. By giving the front of the card a very artistic treatment and by relegating the factual information to the reverse, the recipient is hooked immediately. So intriguing is it that one is even inspired to read the minute copy on the front, which is ominously persuasive in its own right: "Even without water for a moment is hard to bear. Just imagine what will happen if we are short of blood."

DIRECTORY OF CONTRIBUTORS

30sixty design, inc
2801 Cuhuenga Boulevard West
Los Angeles, CA 90068
E-mail: jennifer@30sixtydesign.com
page 33

5D Studio
20651 Seaboard Road
Malibu, CA 90265
E-mail: jane5d@aol.com
page 170

AdamsMorioka
9348 Civic Center Drive, Suite 450
Beverly Hills, CA 90210
E-mail: sean@adamsmorioka.com
pages 16,110

Addison
79 5th Avenue, 6th Floor
New York, NY 10003
E-mail: info@addison.com
pages 69, 70, 73

Ana Couto Design
Rua Joana Angélica 173/3° Andar
Ipanema
22420 030 Rio De Janerio
Brazil
E-mail: acgd@anacouto-design.com.br
pages 29, 137, 171

Anne-lise Dermenghem
7, Rue Édouard Nortier
9-2200 Neuilly-sur-Seine
France
page 14

Arthur Andersen Company
133 Peachtree Street, NE, Suite 2500
Atlanta, GA 30303-1845
page 51

Autre, Planètes
132 Rue Blomet
75015 Paris
France
E-mail:
thierry.carbonnel@autre-planetes.fr
pages 88, 124, 126

Base Art Co.
112 Oakland Park Avenue
Columbus, OH 43214
E-mail: base@ee.net
page 27

Belyea
1809 7th Avenue, Suite 1250
Seattle, WA 98101
E-mail: patricia@belyea.com
pages 26, 61, 163, 164

Boelts Bros. Associates
345 East University Boulevard
Tucson, AZ 85718
E-mail: bba@boelts-bros.com
page 66

Braue Design
Parkstrasse 1
27580 Bremerhaven
Germany
E-mail: info@brauedesign.de
pages 87, 129

Delancey Design
2936 Whittier Court
Ann Arbor, MI 48104
E-mail: jdelance@umich.edu
page 18

Designation Inc.
53 Spring Street, 5th Floor
New York, NY 10012
E-mail: mikequon@aol.com
pages 39, 112

EAI
887 West Marietta Street, NW
Suite J-101
Atlanta, GA 30318
E-mail: d_gahan@eai-atl.com
page 114

Eisenberg & Associates
3311 Oaklawn Avenue
Dallas, TX 75219
pages 182, 184

Erwin Zinger Graphic Design
Bunnemaheerd 68
9737 Re Groningen
Netherlands
E-mail: erwin_zinger@hotmail.com
page 98

Format Designgruppe
Never Kamp 30
20357 Hamburg
Germany
E-mail: ettling@format-hh.com
pages 79, 116, 117

Formgefühl
Latropsweg 5
20255 Hamburg
Germany
E-mail: marius@formgefuehl.de
pages 154, 155

Get Smart Design Co.
899 Jackson Street
Dubuque, IA 52001-7014
E-mail: getsmartjeff@movci.net
pages 103, 135

Graif Design
165 East Highway CC, Suite P
Nixa, MO 65714
E-mail: mattgraif@aol.com
pages 96, 100, 130

Greco Design Studio
Via Reggio Emilia 50
00198 Rome
Italy
E-mail: Greco_design@flashnet.it
page 80

Greteman Group
1425 East Douglas
Wichita, KS 67214
E-mail:
sgreteman@gretemangroup.com
*pages 20, 47, 50, 52, 54, 93, 125,
157, 160, 161*

Gottschalk + Ash International
Böcklinstrasse 26, Postfach 1711
8032 Zurich
Switzerland
E-mail: Gottashintl@access.ch
page 17

Hoffmann & Angelic Design
317-1675 Martin Drive
White Rock, BC V4A 6E2
Canada
E-mail:
hoffman_angelic@bc.sympatico.ca
page 24

Hollis Design
344 7th Avenue
San Diego, CA 92101
E-mail: sparky@hollisdesign.com
page 139

Hornall Anderson Design Works, Inc.
1008 Western Avenue, Suite 600
Seattle, WA 98104 144,
E-mail: c_arbini@hadw.com
pages 89, 118, 144, 181

i. wood creative works
2604 Naylor Hall
Marietta, GA 30066
E-mail: i.wood@mindspring.com
page 44

Jamison Shaw Hairdressers
3330 Piedmont Road
Atlanta, GA 30305
Web site: www.jamisonshaw.com
page 84

Julia Tam Design
2216 Via La Brea
Palo Verdes, CA 90274
E-mail: taandm888@earthlink.net
pages 23, 56, 94

Kan & Lau Design Consultants
28/F Great Smart Tower
830 Wanchai Road
Hong Kong
E-mail: kan@kanandlau.com
pages 168, 187

Kenzo Izutani Office Corporation
1-24-19 Fukasawa 37, 150
Setagaya-ku
Tokyo 158-0081
Japan
E-mail: Izutanix@tka.att.ne.jp
pages 36, 37, 150

Lambert Design
4139 Via Marina, Suite 607
Marina del Rey, CA 90292
page 175

Lidji Design Office
2200 North Lamar, Suite 209
Dallas, TX 75202
page 122

Lieber Brewster Design, Inc.
19 West 34th Street
Suite 618
New York, NY 10001
E-mail: lieber@interport.net
page 86

Love Packaging Group
410 East 37th Street North
Plant 2, Graphics Dept.
Wichita, KS 67219-3556
E-mail: dcommer@lovebox.com
pages 25, 59, 60, 134

Lowercase, Inc.
213 West Institute Place, Suite 705
Chicago, IL 60610
E-mail: timbruce@lowercaseinc.com
pages 22, 55, 180

Lunar Design
537 Hamilton Avenue
Palo Alto, CA 94301
E-mail: heather@lunar.com
page 109

Melia Design Group
905 Bernina Avenue
Atlanta, GA 30307
E-mail: faye@melia.com
page 83

Metalli Lindberg Adv.
Via Garibaldi, 5/D
31015 Conegliano Treviso
Italy
E-mail: lionello.borean@nline.it
pages 75, 76, 108, 111

Mires Design, Inc.
2345 Kettner Boulevard
San Diego, CA 92101
E-mail: dara@miresdesign.com
pages 115, 151

Nesnadny + Schwartz
10803 Magnolia Drive
Cleveland, OH 44106
E-mail: Info@nsideas.com
page 38

Oh Boy, A Design Company
49 Geary Street, Suite 530
San Francisco, CA 94108
E-mail: rviaton@ohboyco.com
page 15

Orange
402-1008 Homer Street
Vancouver, BC V6B 2X1
Canada
E-mail: pulp@istar.ca
pages 136, 165

Pepe Gimeno—Proyecto Gráfico
Cadirers, s/n—Pol. D'Obradors
46110 Godella
Valencia, Spain
E-mail: gimeno@ctv.es
pages 49, 120, 179

Producciones Osoxile S.L.
Perill 26, Bajos
08012 Barcelona
Spain
E-mail: info@osoxile.com
page 158

R2 Design
Praçeta D. Nuno Álvares Pereira
20 5° FQ 4450-218
Matosinhos, Portugal
E-mail: r2design@mail.telepac.pt
pages 19, 121, 153

RBMM
7007 Twin Hills, #200
Dallas, TX 75231
E-mail: rbmm@rbmm.com
pages 132, 145, 146

ReDesign
Tweeddale Court
14 High Street
Edinburgh, Scotland
E-mail: regina@regina-fernandes.co.uk
pages 91, 92

The Riordon Design Group Inc.
131 George Street
Oakville, Ontario L6J 189
Canada
E-mail: ric@riordondesign.com
page 102

Sagmeister Inc.
222 West 14th Street
New York, NY 10011
E-mail: ssagmeiste@aol.com
page 34

Sayles Graphic Design
3701 Beaver Avenue 177
Des Moines, IA 50310
E-mail: sayles@saylesdesign.com
pages 46, 119, 149, 177

Somberg Design
1811 Independence, #19
Ann Arbor, MI 48104
E-mail: msomberg@rust.net
page 18

Steven Verriest
380 N. Crooks, #87
Clawson, MI 48017
E-mail: verriest@yourartslave.com
page 104

Stewart Monderer Design, Inc.
10 Thacher Street, #112
Boston, MA 02113
E-mail: sm@monderer.com
pages 90, 156

Studio GT & P
Via Ariosto, 5
06034 Foligo (PG)
Italy
E-mail: gtandp@cline.it
pages 97, 131

Studiografix
9108 Chancellor Row
Dallas, TX 75247
page 21

SuZen Creations
55 Bethume Street, #D816
New York, NY 10014
E-mail: suzen@infohouse.com
pages 53, 148

Terrapin Graphics
991 Avenue Road
Toronto, Ontario M5P 2K9
Canada
E-mail: james@terrapin-graphics.com
pages 12, 13

Trickett & Webb
The Factory
84 Marchmont Street
London WC1N 1AG
United Kingdom
E-mail: lynn@tricketts.co.uk
pages 140, 167

Vista, Inc.
Fire Station No. 16
822 Marietta Street
Atlanta, GA 30318
page 41

Vrontikis Design Office
2021 Pontius Avenue
Los Angeles, CA 90025
E-mail: pv@35k.com
pages 67, 176

Whitney Edwards, LCC
14 West Dover Street
Easton, MD 21601
E-mail: charlene@wedesign.com
pages 162, 186

Williamson Printing Corporation
6700 Denton Drive
Dallas, TX 75235
page 101

Wood/Brod Design
3662 Grandin Road
Cincinnati, OH 45226
page 133

X Design Company
2525 West Main Street, #201
Littleton, CO 80120
E-mail: alexv@xdesignco.com
page 62

Yfactor, Inc.
2020 Clark Boulevard, Suite 1B
Brampton, Ontario L6T 5R 4
Canada
E-mail: info@yfactor.com
pages 78, 112, 178

ABOUT THE AUTHOR

Cheryl Dangel Cullen is a writer and marketing consultant with an extensive background in the graphic arts industry. She is the author of *Graphic Design Resource: Photography* and *The Best of Annual Report Design*, both published by Rockport Publishers. She writes frequently on the subjects of graphic design, paper, and printing, and has contributed articles to *How Magazine*, *Step-by-Step Graphics*, *Graphic Arts Monthly*, *American Printer*, *Printing Impressions*, and *Package Printing & Converting*, among others. In addition, she gives presentations and seminars on innovative ways to push the creative edge in design by using a variety of substrates.

Cullen writes from her home near Ann Arbor, Michigan. There, she oversees operations for Cullen Communications, a public relations firm she founded in 1993. Cullen specializes in orchestrating public-relations campaigns and advertising programs, including writing and design projects, for a national base of business-to-business and consumer clients.